THE YORKSHIRE COINERS

THE TRUE STORY OF THE CRAGG VALE GANG

STEVE HARTLEY

AMBERLEY

This edition first published 2023

Amberley Publishing
The Hill, Stroud
Gloucestershire GL5 4EP

www.amberley-books.com

British Library Cataloguing in Publication Data.
A catalogue record for this book is available from the British Library.

ISBN 978 1 3981 1387 9 (print)
ISBN 978 1 3981 1388 6 (ebook)

Typesetting by SJmagic DESIGN SERVICES, India.
Printed in Great Britain.

CONTENTS

FOREWORD

This book covers the history of coining in Yorkshire generally, but the primary focus is the events surrounding a gang of criminals operating in the area to the west of Halifax, whose effect on the coin in the kingdom was acknowledged at the highest levels in government. This resulted in the Houses of Parliament being drawn into debate over the affairs of the gang, and officers of the Royal Mint being despatched to apprehend its members.

Less than 10 miles due south of Haworth in West Yorkshire, where Charlotte, Emily and Anne Bronte grew up in the early nineteenth century, the same rugged landscape that inspired *Wuthering Heights* played host to a sinister story of organised social crime, high treason and ultimately murder, some forty years before the Bronte sisters were born.

If the story of the Cragg Vale Coiners was a work of fiction it would rank alongside the likes of *Treasure Island*, *Robin Hood* and *Oliver Twist*. The fact that it is a true story places its participants alongside infamous criminal legends such as Black Beard (Edward Teach), Jesse James and Dick Turpin.

In fact, the gallows at York Tyburn that ended the career of Dick Turpin in 1739 were also used to bring many Coiners from Yorkshire to justice before and after Turpin's execution.

Coining had been practised for as long as coins had been used as a means of payment for goods, but in most cases, this was carried out by individuals or small groups, as the early part of this book will illustrate.

The Cragg Vale Coiners, on the other hand, became well organised and they involved numerous people within the local community in one form or another, such that few of the locals remained untouched or unaffected.

In an early report to the government at the time, it was declared that nearly three and a half million pounds worth (equivalent to over £220 million today) of diminished coin had been paid into banks at the Mint price during the reign of the Cragg Vale Coiners. The coin was found to be deficient on average by 9 per cent.

This sum of deficient coin in this early report was later found to be grossly underestimated when a later report indicated that the actual quantity of deficient gold coin circulating was over sixteen and a half million pounds worth (equivalent to £2.3 billion today).

The Cragg Vale Coiners clipped and filed the edges of gold coins and returned the clipped coins to circulation. They then used the gold collected from several coins to cast blanks and stamp new coins. This method was much simpler than mixing base metals or plating base metal to produce a fake, which were the

methods generally used by other Coiners. It also produced a coin that had an actual value in gold, albeit that the process involved devaluing several genuine coins to obtain the gold required.

But beyond the small corner of Yorkshire in which the gang operated, the name of the Cragg Vale Coiners is not so widely known today. Much of the interest is due to the modern popularity of genealogical studies, where the researcher discovers they may have a skeleton in their family's closet through a link to a member of the Coiners gang.

By drawing up the family tree some years ago, my grandfather proved that we were descended directly from David Hartley, or 'King David' as he became known, the leader of the Cragg Vale Coiners.

Consequently, my own interest in my family history and their involvement in forming and leading the gang that had such a substantial effect on the currency of the country at the time, has always been high. Over the years I have collected several books, documents and other items to help further my research. In recent times the internet has become an invaluable research tool, providing access to the catalogues of various archives.

The story of the Cragg Vale Coiners and the facts surrounding them has appeared in various forms previously. From factual books to fictional children's stories and from poems to folk songs, to plays and potentially being developed into a feature film with Peter Kershaw's *The Last Coiner* project.

The story has also most recently been the subject of the very successful fictional novel *The Gallows Pole* by Benjamin Myers, which won the Walter Scott Prize for Historical Fiction in 2018. In May 2021 it was announced that *The Gallows Pole* was to be dramatized for television for the BBC by renowned British director Shane Meadows and at the time of writing, filming was ongoing.

The factual books on the subject are of varying degrees of accuracy, but the one that was previously considered to be the most accurate was the work by Henry Ling Roth.

Ling Roth was an English-born anthropologist, active in Australia. He was educated at University College School, London, and studied natural science and philosophy in Germany. In June 1900, Ling Roth was appointed honorary curator of the Bankfield Museum, Halifax, which was in a rather neglected condition at the time. Ling Roth soon changed this, and in 1912 was appointed half-time keeper and later, he became full-time curator of the museum.

In January 1906 Ling Roth was presented with a series of notes made by Francis Alexander Leyland, by the local historian's son John. Leyland had given a lecture about the Cragg Vale Coiners in 1886 after studying the papers of Halifax solicitor Robert Parker. Robert Parker was one of the men that eventually brought the activities of the Coiners in the area to an end.

Having studied Leyland's notes and the papers from Parker that were enclosed with the notes, Ling Roth published *The Yorkshire Coiners, 1767-1783, and Notes on Old and Prehistoric Halifax* in 1906.

The first section of Ling Roth's book gave an account, using extracts from the newspapers and letters of the time, of the rise and fall of not only the local Cragg Vale Coiners, but some of the other Coiners elsewhere in Yorkshire.

Papers
Relating to the Coiners
of the
Neighbourhoods of Mytholmroyde
and Halifax
—

The assassination of Deighton;
and other proceedings consisting of
examinations, confessions and informations
on the clipping and dimminishing
of the coin of the realm,
as well as the practices of counterfeiting the same.

circa 1765 –1770

This Book together with the Original Documents were
presented to me by John Leyland in January 1906
Philip Roth

Presented to the Halifax Antiquarian Society
1913
H & R.

The inscription in the front of Leyland's notes in the Halifax Archives.

It contained descriptions of people suspected of coining and murder, and included transcriptions of newspaper reports, witness statements, trial papers and details of sentencing, which in some cases was execution. This part of the book also discussed the state of the coinage and currency of the time and the government's policy towards clipping and coining.

The second section of Ling Roth's book told of the ancient history of Halifax and includes sketches of old Halifax, details of the woollen trade, civil wars, house building, gibbet, the Piece Hall, and old Halifax families.

The first part of the book is therefore of prime interest here, describing the facts relating to the Coiners. It also described and illustrated the various artefacts remaining from the Coiners that were held at the Bankfield Museum, to which Roth therefore had access.

Whilst the book does contain some of the facts and details required, it is often difficult to follow the story since the particulars are not always presented in sequence and the distinction between the various documents and Ling Roth's commentary is not always apparent. Some of the key information are also contained within footnotes rather than the body of the text.

Some of the documentation referred to can be difficult to understand due to the language and expressions used at the time they were written and there is little in the way of explanation throughout.

Another often used source of information is the book *Clip a Bright Guinea, the Yorkshire Coiners of the Eighteenth Century* by John Marsh, first published in 1971. Marsh's book does arrange the facts in order better than Roth's book, but it was not as comprehensive and did not include as many transcriptions from actual documents. In some instances, the author only speculated as to what might have happened, introducing an element of fiction to fill the gaps.

The Yorkshire Coiners: The True Story of the Cragg Vale Gang brings together the facts from these and other sources and places them in chronological order, so that the events relating to the Coiners can be seen in the order they occurred. The source of the information is quoted throughout and where applicable, comments are included on the likely accuracy of the information.

In compiling the book, as many of the original sources as can be seen have been re-examined, including the collection of papers of Robert Parker that had been studied originally by Leyland. These are now held with Leyland's notes by the West Yorkshire Archive Service (WYAS) and the original archive material can be viewed at the Calderdale (Halifax) offices.

On examination of these papers, some additional details were found which had not previously been included in Ling Roth or Marsh's books, including prosecution briefs for other Coiners and the last speech and confession of Thomas Spencer, one of the Coiners gang.

During my research, a great deal of additional information was discovered in other archives, and it is the inclusion of this extra information which makes this book a fully comprehensive account of the Yorkshire Coiners.

In addition to the records held in Calderdale, the records of The National Archives (TNA) at Kew have been searched and many other documents, principally assize records, Mint records, and Government correspondence,

which have not previously been published, have been located, reviewed, and described.

Additional documentation has also been discovered in the Wentworth Woodhouse Muniments (WWM) which are held at the Sheffield City Archives. These documents generally consist of correspondence sent and received by Charles Watson Wentworth, the Marquis of Rockingham, who played a significant role in bringing the Coiners to justice.

By checking the reports in the newspapers of the time which are generally held on microfiche in the Leeds Central Library (LCL), additional details of arrests and court proceedings have also been uncovered and the details included. Indeed, the accounts given by Henry Ling Roth and John Marsh previously actually represent only a tiny fraction of the information that exists in the various archives.

Many of the documents use varying spellings of names, such as Deighton/ Dighton, Normanton/Norminton, and so on, so to avoid confusion, the most common spelling in each case has been used throughout the book.

<div align="right">Steve Hartley</div>

1

EARLY COINING CASES IN YORKSHIRE

As the foreword to this book suggests, the practices of clipping and coining[1] had been carried on throughout the kingdom for as long as coins had been used as a means of payment in trading. This chapter examines some of the early cases in Yorkshire and the legal processes used to determine punishment.

Several people from various parts of the county found themselves imprisoned after being caught either practising clipping or coining, or because of attempting to pass a false coin, all of which were offences of High Treason.

The Treason Act was passed by Parliament in 1351[2] and distinguished between offences of High Treason and Petty Treason. The former was an act of disloyalty to the sovereign and the latter an act of disloyalty to a subject.

High Treason included offences such as plotting the death of the King, levying war against the King, counterfeiting the Great Seal or Privy Seal, killing the Chancellor, Treasurer, one of the King's Justices or Judges, and counterfeiting English coinage or importing counterfeit English coinage.

Petty Treason entailed offences relating to the murder of a lawful superior, for example a servant that murdered his master, a wife that murdered her husband or a clergyman that murdered his prelate.

The distinction between the two types of offence was the consequence of being convicted. For High Treason, the penalty was death by hanging, drawing, and quartering (for a man), or drawing and burning (for a woman). The traitor's property would also transfer to the Crown. For Petty Treason the penalty was hanging and drawing without quartering, or burning without drawing. Property transferred only to the traitor's immediate Lord.

In 1697, an Act of Parliament that was subsequently made permanent in 1708,[3] made the forgery of gold and silver coin an offence of Treason. The penalty for coining was death.

It was possible to make worn silver shillings and sixpences look like worn gold guineas or half guineas, or to make worn half pennies or farthings resemble worn shillings or sixpences by plating them or treating them with a chemical wash.

Consequently, a further Act in 1742 then made it Treason to make a lower denomination coin resemble a higher denomination coin.

Until 1771 the offence of coining only applied to gold and silver coin. Counterfeiting copper coins was treated as a misdemeanour and only carried a two-year prison sentence. The offence of counterfeiting copper coin was finally raised to felony status in 1771.

The cases of Coiners in Yorkshire were generally heard at the assizes court in York and offenders from the whole of the county would be sent to the gaol at York Castle to await trial.

The assize courts heard the most serious cases which were committed to it by the quarter sessions (local county courts held four times a year). The types of cases covered by the assizes included murder; rape; highway robbery; burglary; horse, sheep, or cattle theft; and of course coining.

Minor offences were dealt with by Justices of the Peace in petty sessions (also known as magistrates' courts) which were usually held monthly.

The assize courts continued until 1972 when, together with the quarter sessions, they were abolished by the Courts Act 1971 and replaced by a single permanent Crown court.

The Assizes were presided over by London-based judges known as 'Justices of Assize', who were judges of the King's Bench Division of the High Court of Justice.

Twice a year, normally during Lent in February and March and in Trinity during July and August, Judges rode their 'circuit' on horseback from one county town to the next, trying all the people brought up before the assizes who had been charged with more serious criminal offences that could not be dealt with by the quarter sessions or magistrates.

York belonged to the Northern Circuit, which covered the counties of Cumberland, Durham, Lancashire, Northumberland, Westmorland, and Yorkshire, together with the City of York and the county towns of Newcastle-upon-Tyne and Kingston-Upon-Hull.

Prisoners had been held in York Castle since the thirteenth century but by the end of the seventeenth century the buildings had fallen into disrepair.

A new county gaol was built and opened in 1705. The new gaol building served a dual purpose, housing felons accused of the most serious crimes on its ground floor, and debtors on the first and second floors.

Alongside the debtors' prison as it is known, stood a courthouse building which was rebuilt in 1674–75. The present courthouse building was built later in 1777 and the female prison opposite the courthouse was added in 1783.

Between the assize sessions the gaol could become overcrowded with prisoners awaiting trial, particularly during winter due to the extended period until the spring assizes.

The conditions in the York gaol were very poor, with felons sleeping on stone-flagged floors with straw for bedding. They survived on a rationed diet of bread and water.

Initially the felons area consisted of large chambers, but due to a mass breakout in 1732, these areas were broken down into smaller cells, which were usually shared by up to six men. Separate cell areas affording more space were reserved for those who had been convicted and were sentenced for either transportation or execution.

All prisoners were confined to their cells during the night from dusk to dawn, which in winter could be between fourteen and sixteen hours.

An open internal 'day' area outside the cells allowed the prisoners to circulate during the daytime. Prisoners could also leave these day areas to an enclosed

external courtyard between the wings of the prison. This felons courtyard was separated from the more open debtors exercise area by a fence across its front. Being north facing and sheltered by the gaol building, this courtyard rarely saw direct sunshine.

The two exercise areas were separated by a railed fence and with the public having access to the debtors courtyard, communication was still possible between the felons and the outside world through the rails of this fence.

Most felons wore heavy leg irons throughout their term in gaol. These were fastened at the waist and the ankles to restrict their movement and prevent escape over the fence. When the gaol was particularly full there was often a shortage of leg irons, so these would be reserved for the most valuable prisoners or those most likely to escape.

The cells were typically 7.5 feet long, 6.5 feet wide, and 8.5 feet high. Most had no external ventilation and only small ventilation holes in the door or a small opening above the doorway. On the night of 27 October 1737, nine men confined to a single cell died of suffocation due to the lack of ventilation.

The gaol was also rife with diseases such as smallpox, typhus, cholera and tuberculosis and an open sewer ran through the felons' area to collect the slops in the morning. Consequently, many prisoners became sick and died either from disease, suffocation or malnutrition before they faced trial.

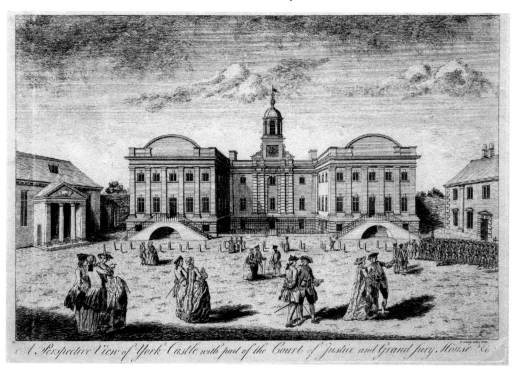

A perspective view of York Castle with part of the Court of Justice and Grand Jury House by William Lindley in 1759. (Image courtesy of York Museums Trust https://yorkmuseumstrust. org.uk)

The gaol was run as a private enterprise and rented from the Sheriff by the gaoler. Prisoners with access to money could buy themselves marginally improved conditions, perhaps in the form of better food rations, ale, wine or more comfortable bedding, all of which could be bought from the gaol servants at an inflated price.

Whilst the punishment for many crimes was execution, this was not used as frequently as might have been thought. In fact, just over 5 per cent of cases resulted in execution. Some of those convicted were branded and many were transported, but most of those accused of crimes were acquitted.

Execution was usually reserved for those that had committed particularly heinous crimes, or perhaps where a public example needed to be made. At this time, execution by hanging meant death by slow strangulation from the convicted person's own weight on the rope and they were typically left for half an hour to ensure they had fully expired. In later years the long drop would result in a swift death by breaking the neck.

All cases at York resulting in execution were compiled into the *Criminal Chronology of York Castle* by William Knipe in 1867. Knipe's book described the cases that resulted in the execution of prisoners from York Castle gaol for a variety of charges, dating back to the first execution which was Edward Hewlson, aged twenty, who was hanged on 31 March 1379 for rape. Some cases are described only briefly, while others such as that of the famous highwayman Dick Turpin are described in greater detail.

Those found guilty and sentenced to death were usually executed at York Tyburn. Gallows had been located at the Knavesmire (part of York Racecourse) since Hewlson's execution in 1379 and had three beams arranged in a triangle, supported by three uprights which gave it its name, the 'Three-Legged Mare'. Prisoners were transported to it in horse-drawn carts, sitting on their own coffins and with the noose already around their necks.

Executions continued at York Tyburn until 1801, by which time it was felt that having executions carried out on one of the major routes into the city did not give a good first impression to visiting travellers. So, executions were moved to a

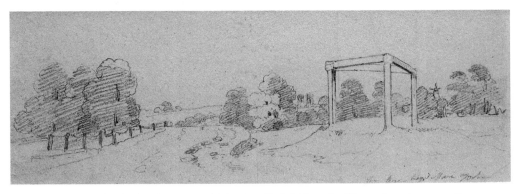

A pencil sketch of 'The Three-Legged Mare' at York Tyburn by Henry Cave in 1795. (Image courtesy of York Museums Trust https://yorkmuseumstrust.org.uk)

new location near the York gaol, where they were still a popular public occasion. The gallows at York Tyburn were finally removed in 1812 after a decade of being unused.

All cases of Coiners detailed in Knipe's book indicated that in many cases the person convicted of the crime faced the charges alone. There are some cases where small groups have been sentenced and executed together. This would have been due to the timing of the assizes rather than them being part of the same gang as in many cases, the people executed came from differing parts of the county.

The list of Coiners who were capitally convicted at York for coining offences and hanged for their crimes was listed in Knipe's book, together with details of their ages, hometown and the offence committed.

The first case recorded for coining offences was on 27 March 1575 with Frederick Gottfried from Hull, and Thomas Conrat of Keswick, Cumberland, where both men were convicted for coining guineas. Over the next 120 years almost forty more people would be convicted and executed for coin crimes.

On 10 August 1698, John Blackburn of Dunnington near York was the last man to be executed at York Tyburn for coining activities until the sequence of events started in the Cragg Vale area to the west of Halifax.

Photograph of the site of the gallows at York Tyburn.

The people that had been prosecuted and executed to date within the county appeared to have been acting alone or in small groups. Many were young people, possibly prepared to take a chance of making a small amount of money when weighed against the risk of being caught.

The Cragg Vale Coiners were different in that they became methodical and organised. They developed strong leadership and distinct methods to collect and clip coins, then returned the clipped and new counterfeit coins to circulation.

Their methods ensured that those that supplied coins to be clipped also made a small amount of money. Because everyone made a small financial gain, not just the Coiners themselves, this helped win support locally and contributed to their effectiveness.

2

CRAGG VALE, COINS AND LAW

It is appropriate to set the scene by describing the location of the heartland of the Coiners' activities and the people that lived there. It is also worth considering the state of the coin at the time and of course the means of local law enforcement, which were undoubtedly contributory factors to the effectiveness of the gang.

This gang of Yorkshire Coiners is often referred to as the Cragg Vale or Turvin Coiners due to their base being in an area just off the Calder Valley in West Yorkshire.

West Yorkshire (or the West Riding of Yorkshire as it was known at the time) had three main valleys running towards the Pennine fringe of the county towards Lancashire. The Colne, Calder and Aire valleys were all served by cross Pennine routes and the area between the valleys was known as the wool district.

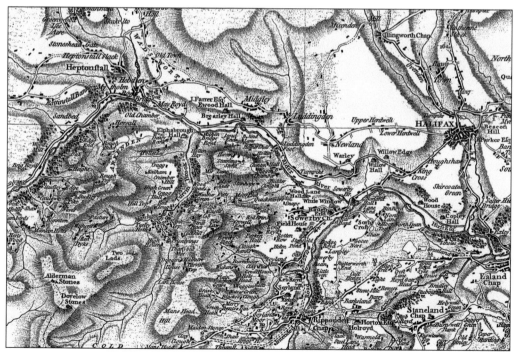

Extract from the 1771 County of York map by Thomas Jeffreys.

The Calder Valley lies midway between Manchester and Leeds. The settlements of Walsden, Todmorden, Hebden Bridge, Mytholmroyd and Sowerby Bridge lie along the base of the valley from east to west, with the towns and cities of Burnley, Bradford, Halifax and Huddersfield in the immediate surrounding area. The name of the valley is derived from the River Calder that runs through the valley from west to east.

The valley sides in this part of Yorkshire are particularly steep and from the Middle Ages, small homesteads were mostly situated on the shoulders of land on the valley sides between the heavily forested and marshy valley bottom and the open moorland on the tops.

Due to the difficulty of farmers living off the land alone, handloom weaving was generally used to supplement the income from farming.

As the weaving industry developed, settlements grew up around the homesteads to form the villages of Heptonstall, Luddenden and Sowerby. Weaving during this early period was a cottage industry with groups of people working from home.

Supplies and produce were carried between villages by packhorses using paths across the tops. Where the paths crossed the valley floor and the River Calder, an inn was often built alongside the crossing which encouraged further settlement. This was the case at Hebden Bridge, Mytholmroyd, Todmorden and Sowerby Bridge.

In the late sixteenth and early seventeenth centuries, merchant clothiers organised the domestic industry, and developed markets overseas which helped the industry prosper. Not least was the export of worsted cloth (also known as stuff) which was a high-quality, hard-wearing cloth, originally produced in the village of Worstead in Norfolk.

Daniel Defoe, best known as the author of *Robinson Crusoe*, was also an accomplished travel writer, and between 1724 and 1727 his three-volume travel book *Tour through the Whole Island of Great Britain* was published.

Defoe described his visits to all parts of the country and in Letter 8 he described the area of West Yorkshire with references to the Calder Valley and its industrious inhabitants.

Defoe described the second of these journeys and the difficulties he experienced in coming down Blackstone Edge in a snowstorm, during which he almost lost his life. On arriving at the base of Blackstone Edge he then described the route along the undulating valley with its houses interspersed throughout. His description of the journey along the valley paints a vivid picture of the features of the landscape and the lives of the local population.

He noted the apparent absence of people but found that they were hard at work in their houses producing cloth. He also identified that the reason the houses were distributed so sparsely was to be close to coal deposits and water, upon which the woollen business was dependant.

In the fifty years after Defoe's journey through the valley it is unlikely to have changed a great deal, but by the time the local people turned their hands to clipping and coining, the prosperity of the region's weaving trade had suffered a setback.

In his book *Crime and Punishment in the Eighteenth Century*,[4] Frank McLynn suggested that after a boom during the Seven Years' War (1756–63), the woollen industry in the West Riding of Yorkshire fell into decline during the post-war recession. This was due to a reduced demand for worsted which had been manufactured in the area and used largely for military uniforms.

Combined with a shortage of cash generally within the country, this led to an acceptance locally of clipped or remanufactured coins as the only means of continuing business in the absence of genuine, unclipped coins.

It is likely that this acceptance and the need for some means of supplementing the reduced income of the weavers is what determined the needs of the local population to take part in, or in some way assist, the activities of the Coiners.

Many of those involved with the Cragg Vale Coiners had trades associated with the weaving industry. The occupations of those accused of clipping and coining in the area were summarised by John Styles in his essay *Our Traitorous Money Makers*[5] as follows:

Textile Occupations

Clothier (4)
Master cloth dresser (1)
Piece maker (14)
Dealer in wool or yarn (2)
Wool comber (7)
Weaver (24)
Total: 52

Other Occupations

Farmer (1)
Farmer/weaver (3)
Husbandman/weaver (1)
Miller (1)
Innkeeper (10)
Butcher (3)
Clockmaker (2)
Painter/engraver (2)
Tanner (1)
Carpenter (1)
Healdstriker/staymaker (1)
Badger/weaver (1)
Labourer/charcoal burner (1)
Total: 28

The prevalence of innkeepers, butchers and clockmakers is an indication of the means of obtaining gold and returning it to circulation. Many of the men involved

in the textile trade as workers and small manufacturers would not have regular access to such coins when compared to these trades.

Styles noted that one of the accused merchants and one of the wool combers were bankrupts, and two of the worsted piece makers had been imprisoned previously for debt, which supports the theory that many took part in the activities of the gang due to financial pressures.

The first proper transport route along the Calder Valley was the turnpike road, which was built in 1761 shortly before the events in this book.

The arrival of the canals in the latter part of the eighteenth century saw the Calder and Hebble navigation reach Sowerby Bridge by 1794, and then the construction of the Rochdale Canal from Sowerby Bridge meant that the canal was extended to Todmorden by 1799 with a complete cross Pennine route via the Calder Valley by 1804.

As the Industrial Revolution took hold, canals brought coal and raw materials to feed the mills that sprung up along the valley and then transported the completed cloth away. Much later than the day of the Coiners, the construction of the Manchester and Leeds Railway closely followed the route of the canal and opened in 1841.

A journey through the modern-day Calder Valley often sees the river, road, canal and railway running parallel in very close proximity to one another. But much of this appeared after the Coiners were extinct, so at the time only the river and the turnpike road existed. The settlements were well established though and it was the area surrounding Mytholmroyd that was to become the Cragg Vale Coiners' heartland.

To the south of Mytholmroyd, another valley runs into the hillside and away into the moors towards Huddersfield. Part-way up this valley lies Cragg Vale, a small cluster of houses clinging to the valley sides. It is this small village that gives its name to the valley and hence the name of the Cragg Vale Coiners, since the homes of the leaders of the gang were on the moorland immediately above this area. The small river that tumbles down through the valley towards Mytholmroyd where it becomes the River Elphin is called the Turvin Brook and gives rise to the alternative name of the Turvin Coiners.

Away from the main settlements, the farmhouses were often some distance from their neighbours. By modern standards the farmhouses might be considered remote but in fact they were amply served by rough footpaths or cart and packhorse tracks, which generally followed the tops of the hills close to the farms.

The farmhouses and tracks that served them were surrounded by open fields or moorland, so the chances of anyone arriving unexpectedly were slim, giving the Coiners have ample opportunity to tidy away the evidence of their unlawful activities.

During the eighteenth century, England had no public officials corresponding to the modern-day police force. Constables were unpaid and played only a minor role in law enforcement. Halifax, 7 miles away, had two constables and two deputy constables and the nearest magistrate was in Bradford, 14 miles away. The best means of catching criminals in these days was by means of using informants, who would betray their friends and neighbours, tempted by a reward.

But because the conviction of a coining offence carried a sentence of death, when an offender appeared in court jurors were often reluctant to convict the

defendant unless there was overwhelming evidence to support the prosecution. In fact, there was also some reluctance on the part of the Mint to pursue offenders, which was probably due in no small part to the limits imposed on the funds available to pursue prosecutions.

The Mint Solicitor had been responsible for the prosecution of coining offenders since 1715 and as such was required to liaise with, and direct local magistrates in coining cases, and to assist in gathering evidence. The Mint Solicitor's annual salary was only £60 but he received other fees that were proportionate to the works undertaken and his expenditure, for which he had to submit accounts annually to the Treasury.

Between 1709 and 1742 the funds available to the Mint Solicitor for conducting prosecutions against coining offenders was limited to £400 per year, regardless of the number of cases brought to the Mint's attention. This sum only increased to £600 in 1742 but was frequently inadequate. If the annual expenditure went over the capped limit for any one year, there was no statutory obligation that required the Treasury to pay any money at all to the Mint Solicitor.

Fountain Cooke, who was Mint Solicitor between 1748 and 1755, was forced into bankruptcy and emigration because the Treasury refused to pay for the years when his expenditure had exceeded the £600 limit. In a letter to the Lords Commissioners of the Treasury on 12 January 1764, Cooke claimed he was still owed £1,220, and this was only finally settled in 1771.

His successor in 1756 was William Chamberlayne, who would be called upon to carry out the prosecution of the Cragg Vale Coiners. In his first year in post, Chamberlayne exceeded the £600 limit but was careful thereafter to manage his costs well within his limit. In fact, between 1757 and 1769 his annual expenditure was an average of only £298 per annum.

Despite this, whilst most of the money was paid on account, the final balance was often slow in being made up, such that in 1765 Chamberlayne was owed £195 for the previous three years and by 1770 he was owed £550 for the previous five years.

When Chamberlayne was called upon by the Marquis of Rockingham to act on information that had been provided about the Cragg Vale Coiners, the solicitor responded that 'his salary did not allow him to carry on prosecutions'.[6]

The silver and gold coins of this period wore easily due to their soft material, such that the impression on the face was often not clear. The size could also be reduced with wear. Most coins by this time were well worn and overdue for withdrawal from circulation, which led to an acceptance of worn and underweight coins.

The Coiners used this to their advantage by clipping and filing full-weight coins to a weight that was still within an acceptable limit. The trade in the local area ensured that guineas circulated from all parts of the country, providing the Coiners with a regular supply of full-size guinea coins.

Until the introduction of the guinea in 1663, coins had been hand-stamped, where a coin blank would be placed between a pair of engraved dies and hammered to produce the raised pattern. This was the method that the Cragg Vale Coiners adopted in their unofficial mints.

The production of the first guineas coincided with the first milled coins produced mechanically, and though some hand-stamped guineas were produced in the first couple of years, the majority were mechanically produced.

By 1694 at the beginning of William and Mary's reign, the guinea was worth 21 shillings and sixpence, rising to as much as thirty shillings by June 1695.

The currency of the kingdom had been considerably weakened due to an increase in clipping and coining during the Nine Years' War (1688–97). As a result, it was decided to recall and replace all the hammered silver coinage that was in circulation. But the process almost failed due to corruption and mismanagement and was only saved by the intervention of the scientist Isaac Newton, who was appointed Warden of the Mint in 1696.

Newton's knowledge of chemistry and mathematics proved to be of great use in carrying out this English recoinage, and it was completed in around two years. He was subsequently given the post of Master of the Mint in 1699, a post from which he earned between £1,200 and £1,500 per annum.

In 1707, after the union between the kingdom of England and the kingdom of Scotland, Newton called again upon his experience on the earlier English recoinage to direct the recoinage of Scotland between 1707 and 1710. This resulted in a common currency for the new kingdom of Great Britain.

Newton also wrote a report on 17 September 1717 which resulted in the relationship between gold and silver coins being standardised by royal proclamation on 22 December 1717. This prevented gold guineas being exchanged for more than twenty-one silver shillings and became the first gold standard. Newton continued in his position at the Royal Mint until his death in 1727, becoming very wealthy as a result.

The following table illustrates the British coins in circulation, their respective values, and the material from which they were manufactured.

Foreign coinage, which was mainly Spanish and Portuguese money, was also in wide circulation and legal tender alongside the English guinea due to the balance of trade between England, Spain and Portugal at the time. This also assisted the Coiners since these coins not only had a higher value, but they also had geometric patterns on both faces which made them easier to copy than the monarch's head that appeared on guineas.

During this period very little silver coin was produced, largely because the value of silver meant the Royal Mint would make little profit from its production. When King George III came to the throne in 1760 the coin was found to be in a very poor state.[7] The crown pieces had virtually disappeared completely, and the half crowns that remained were generally defaced and impaired such that they were unsuitable for use. The shillings that remained had hardly any impression left on either face. The sixpences were in even worse condition.

The gold coins were not in such a bad condition but were deteriorating, nevertheless. The value of the guinea declined again during the reign of George III because so little silver or copper coin was minted, and it was finally replaced in 1816 by the sovereign.

Coin	Value	Material
Farthing	1/4 Penny	Copper
Halfpenny	1/2 Penny	Copper
Penny	Basic Monetary Unit	Silver
Twopence	2 Pence	Silver
Threepence	3 Pence	Silver
Fourpence	4 Pence	Silver
Sixpence	6 Pence	Silver
Shilling	12 Pence	Silver
Half Crown	30 Pence or 2 Shillings and 6 Pence	Silver
Crown	60 Pence or 5 Shillings	Silver
Half Guinea	126 Pence or 10 Shillings and 6 Pence	Gold
Guinea	252 Pence or 21 Shillings	Gold
Two Guineas	504 Pence or 42 Shillings	Gold
Five Guineas	1260 Pence or 100 Shillings	Gold

Table illustrating the denomination of coins between 1717 and 1797.

The state of the genuine coin, mixed with the prevalence of foreign coins and the fact that the common man rarely handled much money, made the differentiation of a modified coin from a genuine one even more unlikely.

In the *Story of Old Halifax*,[8] Thomas Hanson wrote that the Coiners would pay 22 shillings for a full-size coin and would then clip and shave up to 40 pence worth of gold from it before returning it to circulation for 21 shillings.

The Coiners would then use the gold collected from seven or eight genuine coins to create an imitation Portuguese moidore with a face value of 27 shillings, but they would only use around 22 shillings' worth of gold to create the fake, so making a substantial profit on each new coin they forged.

There was a willingness locally during these hard times to make an extra shilling by lending unclipped guineas to the Coiners. The trade of woven produce carried out by the locals in nearby Halifax provided a regular source of gold coins to be clipped and returned to circulation.

The rugged location, primitive transport links, sparse law enforcement and the poor state of the coinage all created the right climate for the Coiners to exist and prosper.

3

ORIGINS OF THE COINERS

The origins of the Cragg Vale Coiners are not recorded and much of the description of the establishment of the gang is speculation. It is commonly acknowledged that the gang was started by the man that would ultimately lead them, David Hartley.

David Hartley was born in 1730, and had two younger brothers, Isaac and William, and a younger sister, Grace. The three brothers and their sister lived with their father William at Bell House Farm on the edge of the moors above Mytholmroyd, overlooking the Calder Valley.

David Hartley is said to have been apprenticed as an ironworker in Birmingham during the early 1760s.[9] It is believed this is where he learned the darker trade he was to establish in Yorkshire and that he fled Birmingham to avoid arrest. Indeed, one of the later depositions[10] made to the Mint Solicitor suggested that it was David Hartley who brought the trade to Yorkshire and he learned his ways in Birmingham.

Photograph of Bell House, home of the Hartleys.

Birmingham in the mid-eighteenth century was well known for the coining activities that took place there and which drew the attention of the Mint Solicitor from as early as 1744. Most of the coining in Birmingham at this time was related primarily to copper coins.

On 12 July 1751 a royal proclamation was issued by King George II that the Counterfeiting Coin Act of 1741 should be enforced as a warning to the Birmingham Coiners against the consequences of their illegal practices.

Shortly after this the Mint Solicitor acted and had many of the better-known offenders tried and convicted. As they had committed only a misdemeanour due to the offence concerning copper coin, the sentence imposed was generally two years imprisonment.

As a result of the shortage of genuine low-denomination coins, several of the local companies and official bodies started to circulate their own copper coins, which were followed by the production of provincial pennies and half pennies. These were in turn copied and counterfeited by the local Coiners.

The traders and manufacturers of Birmingham met and passed resolutions which condemned the practice, but it continued and by 1753 it was estimated that at least half of the copper coin in circulation was counterfeit.

One man who suffered from the prevalence of counterfeit coin in Birmingham was one of the Industrial Revolution's pioneers, Matthew Boulton. Later in his life in partnership with the Scottish steam engineer James Watt, he would turn his attention to the high-speed production of high-quality coin and in a strange twist, the production of the nation's coin eventually moved to Boulton and Watt's new mint in Soho, Birmingham.

Whilst the production of counterfeit copper coin was at its height in these unofficial mints, the Coiners in Birmingham deliberately avoided gold and silver coins as it was considered too dangerous, and the penalties were too severe.

It is thought that it was during this period that David Hartley had served his apprenticeship and learned the ways of coining. Fleeing arrest in Birmingham, he returned to Yorkshire and gradually established his own coining operations.

David Hartley married Grace Sutcliffe at Heptonstall in 1764 and their first son, David, was born in 1766 with a daughter, Mary, in 1767 another son, Isaac, in 1769. In *Clip a Bright Guinea,* John Marsh suggested that David Hartley returned to Bell House shortly before his first son was born and that Grace was pregnant at the time.

It is not known for certain how the gang was established but as John Marsh plausibly suggested in *Clip a Bright Guinea,* David Hartley would have made discreet enquiries with the assistance of his brothers, probably starting with his neighbours in the nearby farms, John Wilcock of Keelham Farm and David Greenwood of Hill Top Farm.

Both these men are claimed to have taken senior roles in the gang and it is likely that they could have been some of the first to have been approached by the Hartleys. Marsh suggested that Hartley issued an invitation to half a dozen hand-picked men to attend a meeting[11] where he explained how he could ease the hardships these men faced, and that by discreetly recruiting trusted local men to provide a supply of coins for 'treatment' they could all profit and live life more comfortably.

Photograph of Keelham Farm, home of John Wilcock.

In recognition of their positions at the head of the gang, the Hartleys were ultimately given mock-royal titles. David Hartley as the leader was given the title King David and his brothers Isaac and William became the Duke of York and the Duke of Edinburgh, respectively.

Ling Roth indicated that the first written record that coining activities were taking place in the valley was contained in a letter from William Hutchinson who lived in Altona, Hamburg, to Michael Wainhouse in Halifax in early October 1767. Information contained in the Wentworth Woodhouse Muniments[12] in the Sheffield City Archives confirmed that correspondence relating to this case began some months before.

The papers described an Englishman from the Halifax area who had been arrested on suspicion of clipping gold coins. John Greenwood confessed about who had taught him how to clip coins and provided the tools that he used for coining. The archives contain the translation of the inquisition[13] which must have been sent to the Marquis of Rockingham at some stage and is dated 14 August 1767.

The United Kingdom had a diplomatic representative in the Hanseatic League until German unification. Between 1763 and 1772 the representative was Ralph Woodford and was based in Hamburg, which had long been an important port for British trade. Woodford later became 1st Baronet of Carleby in the county of Lincoln which was newly created on 28 July 1791.

Another extract in the Sheffield Archives is recorded as being an extract of a letter[14] from Woodford to Mr Secretary Conway, Hamburg, on 18 August 1767. The letter gave more details about the background of John Greenwood including

details of his father's reputable business as a clothier in Yorkshire and suggested that Greenwood was thought to be of good character which might lead to him being treated leniently by the authorities.

Woodford sent a further letter[15] to Secretary Conway on 22 September 1767, which is again contained in the Sheffield Archives. This second letter enclosed the extract from the inquisition described previously. It also described the punishment Greenwood was expected to face if convicted, being whipped and imprisoned, but indicated that he might have received a pardon if a sum of a thousand dollars could be raised.

Then on 6 October 1767 another letter[16] from William Hutchinson to Michael Wainhouse said that it was unlikely that Greenwood could be saved from punishment since the sum required to prevent it could not be raised. This letter was the one referred to by Ling Roth and referred to the earlier correspondence from Ralph Woodford. It assumed that the information it contained was being acted upon by the government.

It is apparent from correspondence later that the government did not act on the information Woodford sent. When the letter was searched for later, it could not be found and when contacted, Woodford could not recall writing the letter. The final fate of John Greenwood is unknown.

4

COINING ACTIVITIES
INCREASE

On 9 August 1768 the *Leeds Intelligencer*[17] gave a description of some counterfeit coins that were beginning to appear in circulation. The article pointed out some of the flaws in the artwork on the coin faces and errors in the lettering. It also gave details of the weights of the counterfeits.

A few months later, the next mention of coining activities in the area came in the *Leeds Intelligencer*[18] on 10 January 1769, when the paper reported on the appearance of an unnamed Halifax resident who had been charged with attempting to pass false coin. The person managed to find guarantors to secure bail until the next assizes.

Then on 21 February 1769, the *Leeds Intelligencer*[19] reported the arrest of another suspected coiner named Crossley. It indicated that it was hoped his arrest might lead to the arrest of others belonging to the gang that had become established and was operating in the Halifax area and referred to a 'nest of notorious clippers and coiners'.

On 14 March 1769, the *Leeds Mercury* gave a further indication of the presence of an established gang when it reported the arrest of around 'half-a-score' (ten) men in the Halifax area that were sent to the County Gaol, though it is not apparent who was arrested.

Shortly afterwards, information started to come to light in the form of the first of many depositions[20] that would be made about some of the people suspected of clipping coins. This first deposition[21] came on 1 May 1769 from Joseph Broadbent who claimed to have seen John Sutcliffe clip, file and edge some coins, and that he was asked afterwards to go with Sutcliffe and attempt to pass off some clipped coins in Halifax. Sutcliffe lodged with John Broadbent, the father of the man that would come to play a significant part in the Coiners' story, James Broadbent.

On 23 May 1769 the *Leeds Intelligencer*[22] reported the discovery of melted down gold in Leeds and again there was a reference to the activities of clippers. Clipping coins was not unusual, and on this occasion, the gold had been melted down, possibly to be sold as bullion. It is possible that this gold was not the result of the Cragg Vale gang's activities, though the paper did criticise the activities of those diminishing coin. This and the previous reports acknowledged the presence of Coiners in this area of Yorkshire and indicated that their effect was noticeable by this time.

The *Leeds Intelligencer*[23] on 23 May 1769 published details of some counterfeit guineas which were starting to appear in circulation. These appear to have been base metal coated with a gold-coloured covering. A further editorial article in the

Leeds Intelligencer on 23 May 1769 protested the activities of the Coiners and called for government intervention to bring the culprits to justice.

Shortly after, on 18 July 1769 the *Leeds Intelligencer*[24] published a letter in which the writer mocked the apparent acceptance of the practices of clipping and coining locally due to the profit that could be made but warned of its consequences by affecting the ability to trade with other regions. The *Leeds Mercury*[25] on 25 July 1769 then gave a description of some of the false coins in circulation, indicating that they were made of silver with a gilt finish, larger, but lighter than genuine coins.

Consequently, during the summer of 1769, two men began making attempts to identify the Coiners and end their illegal activities. Meetings took place between local worsted manufacturers and leading gentry and at one such meeting on 28 July 1769, Samuel Lister, a Bradford magistrate, and John Stanhope, a Leeds barrister, took matters into their own hands.

The manufacturers' association had employed inspectors to detect embezzlement by outworkers since 1764, so Lister and Stanhope planned to use such inspectors to detect and gather evidence against the Coiners. It was not possible to gather sufficient evidence by association with the coining offenders alone. It was therefore agreed at the meeting that the inspectors could use whatever methods 'they thought necessary and expedient to detect the persons guilty'[26] even if that meant it was necessary for the inspectors to break the law.

James Crabtree, a weaver, and William Haley, a wool comber, who acted as inspectors for the manufacturers, were secretly employed by Lister and Stanhope to detect and inform against the Coiners. In return for the risks they took, they were promised immunity from prosecution together with an appropriate reward.

Before any significant progress was made though, Lister and Stanhope both died within a few days of each other, and James Crabtree was ultimately arrested for the very crime he had been employed to detect.

Fortunately, Crabtree and Haley's real intentions had been shared with two other men: John Hustler, the chairman of the manufacturers' association; and another Samuel Lister, an attorney from Manningham, so the two men were eventually saved.

The thorough work of these men did bring about some arrests though. A handbill produced before the 1770 spring assizes gave details of several men who faced charges on the oath of James Crabtree and William Haley resulting from the investigations instigated by Lister and Stanhope.

The day after Lister and Stanhope's meeting with the worsted manufacturers, a man named Crispin Crowther made a deposition which then led to several others being made. Between them the subsequent depositions gave a great deal of detail about the methods employed by some of the Coiners to produce their 'home-made' coins.

In his deposition[27] made on 29 July 1769, Crowther claimed to have seen Nathan Fielding clip a 36shilling coin that had been given to him by John Waterhouse and that he was paid threepence in return.

In a pattern that would then become common in the story of the Coiners, the person accused of clipping the coins then made a deposition of their own to counter

the accusations being made. Nathan Fielding therefore made his deposition[28] on 31 July 1769 in which he claimed to have witnessed Crowther clip, edge and file a coin. Crowther evidently said that because it was 'brave piece' (meaning it was full weight) he would not use it without taking the opportunity to clip the edges first. Fielding's deposition stated that John Waterhouse, who Crowther also named in his deposition, had told Fielding that he had also seen Crowther clip and file silver coins.

In support of Fielding's statement, John Waterhouse made a deposition[29] the same day which started to add some detail about the methods Crowther used to produce his coins by using a mould made of wood and plaster.

Crowther had asked Waterhouse, a joiner, to make him two pieces of wood with circular hollows in the faces. Waterhouse stated that Crowther later showed him the pieces of wood and saw that the hollows had been filled with plaster into which the impression of the faces of a coin had been made. When fitted together, the wood created a mould for making shillings.

Waterhouse's apprentice, Joseph Hall, also claimed to have witnessed the methods used by Crowther with the pieces of wood made by Waterhouse. He said he'd seen Crowther melt clippings down in a clay pipe and pour the molten metal into the mould to produce counterfeit coins. Hall also made a deposition[30] on 31 July 1769 to record what he had seen, confirming that the moulds had the impression of a head and tail of a coin in them which Crowther used to make shillings.

Whether this series of statements and depositions ever resulted in a prosecution is not apparent.[31]

The depositions were made to Samuel Lister, a Bradford magistrate who was shortly afterwards to take several depositions from James Crabtree and William Haley as they started to make progress towards the discovery of Coiners.

Independently and probably unknown to Lister and Stanhope, another man had started making his own enquiries which would shortly bring about significant arrests. William Dighton was the Supervisor of Excise in Halifax, and had no doubt noticed and felt the effect of the Coiners' activities in the area. His partnership with local solicitor Robert Parker would eventually see many of the Coiners gang convicted and, in some cases, executed for their crimes. For Dighton though, it would tragically result in his untimely death before any Coiners faced trial because of his investigations.

5

THE INSPECTORS

James Crabtree made a statement[32] on 10 August 1769 against Stephen Morton to whom they had lent good coins and had clipped coins returned. The methods used by Crabtree and Haley as proof of the clipping and to detect whether the same coins were returned clipped are interesting to note.

They carefully weighed any coins that they intended to pass for clipping beforehand and marked each coin uniquely. This enabled them to identify the specific coins later if they were returned and compare them against the weights recorded previously.

William Haley made his lengthy deposition[33] the same day supporting the evidence provided by Crabtree. It included more evidence of the meticulous detail that the two men used to prove that the coins they were supplying had been diminished. He confirmed that each of the coins they gave for clipping had particular and unique markings so that they could be identified afterwards and re-weighed.

Throughout their depositions, Crabtree and Haley recorded that they lent full-weight guineas to Morton on various occasions and that he left the room each time for a short period. When he returned, Morton gave them back the guineas and that by checking the markings later, Crabtree and Haley could confirm they were the same coins but were lighter when weighed.

Neither Crabtree nor Haley witnessed Morton clip the coins in person or could give conclusive evidence that Morton had clipped the coins himself. All they could prove was that Morton had taken coins and when they were returned, they had been clipped. Morton was therefore called upon to make his own deposition and did so on 4 September 1769 in a joint statement[34] with another man, Bartholomew Jones.

Both men gave information against John Pickles saying that they had witnessed him clip coins and place the clippings, scissors and file in a wall, which they retrieved later and produced in front of Richard Townley, the Justice of the Peace.

Stephen Morton made a further statement[35] the following day on 5 September 1769 to Richard Townley again. This time he claimed that he had supplied coins to James Crabtree and that they had been returned apparently clipped. Morton also said that when he had threatened to inform against John Pickles, Crabtree had urged him not to do so. But after Crabtree had left him, Morton went to lodge his information with William Dighton and Richard Townley.

With the evidence lodged against Pickles and Morton both men were arrested, as a subsequent newspaper article in the *Leeds Mercury* on 19 September 1769

reported. Crabtree and Haley's investigations were meeting with success and contact was being made with other members of the Coiners gang with apparent ease.

The two men targeted another man who was suspected of coining and on 5 September 1769, William Haley was able to make a new deposition[36] against a man whose name will appear regularly in the events that follow, a man called Thomas Clayton.

As with the information against Stephen Morton, the deposition against Clayton detailed the same methods of marking and weighing the coins before and after. Once again, Crabtree and Haley did not witness Clayton clip the coins in person as he left the room, returning the coins after they had been clipped elsewhere.

James Crabtree made a similar deposition[37] two days later on 7 September 1769, which supported the information that Haley had given previously against Clayton and included information against three other men: Benjamin Sutcliffe, Peter Barker, and James Oldfield.

On 8 September 1769, Haley gave a further deposition[38] against Stephen Morton and included details of the transactions Crabtree and Haley had made with Benjamin Sutcliffe, James Oldfield and Joseph Shaw. James Oldfield was called upon to give his statement[39] on 9 September 1769 and denied any knowledge of clipping coins as Crabtree and Haley claimed.

Whilst Crabtree and Haley still had not directly witnessed any of their suspects clipping coins, there were others that had and were willing to provide evidence of the same. One such person was Joseph Shay who gave two separate depositions against people he had seen clip, file and edge coins. Not only that, but he had seen some of them melt clippings down, form blank disks of gold and then stamp new coins from the gold disks.

Shay's first deposition[40] made on 10 September 1769 gave a great deal of detail about one such unofficial mint run by Isaac Dewhirst and described the process of weighing and melting the gold and stamping the coins using sets of dies. Shay had witnessed Dewhirst clipping coins himself but also named several people as being complicit by supplying clippings of gold to make counterfeit coins.

The statement indicated that Dewhirst possessed several different dies for the purpose of creating the various denominations of coin, and for providing the coining service Dewhirst received a nominal payment for each coin he stamped.

A few days later, 14 September 1769, Shay made another deposition[41] regarding the activities of Dewhirst, describing once more the process of clipping, filing, melting, forging blanks and stamping coins. A few other people were named in this second statement for using Dewhirst's counterfeit service, including the Overseer of the Poor in Warley who was evidently using the clipping and coining to help support his retirement.

The same day, another man, Jonathon Spencer, gave a deposition[42] describing how he and another man, Timothy Pickles, had been tempted to try clipping a coin themselves. Spencer had been encouraged to see how to clip a coin by an innkeeper called James Wood, though Woods' motives were not clear.

THE EXCISEMAN, SOLICITOR AND INFORMANT

William Dighton was the Supervisor of Excise in Halifax and as such he was responsible for the assessment of taxes arising from the production of goods in the area. His role was to co-ordinate and monitor several Excise Officers who would identify and visit the taxed manufacturers in the area and assess the manufacture of goods and produce, recording this in their journals. Once assessed, the officer issued a voucher to the manufacturer recording the taxable production.

These vouchers would be taken to an inn each month which the supervisor would use as an impromptu office. Here the supervisor would take accounts and record the excise due. The taxes would subsequently be collected periodically by the Excise Collector, who in this case was based in Leeds.

The Excise Board minute books, which are held at the National Archives, record details of disciplinary offences, promotion and leave of excise men between 1695 and 1867. These minute books reveal that in 1758, William Dighton had been demoted after failing to administer the Excise Officers in his charge satisfactorily. The entry in the Excise Board minute book for 15 March 1758 detailed the reason for his demotion whilst in post as the Supervisor of Excise for a district of Oxford.

As supervisor he was responsible for the actions of his officers and monitoring the condition of their horses. The Excise Board minutes[43] indicated a lapse in the performance of his duties, leaving two of his officers without horses, which resulted in him being demoted to Excise Officer and relocated to Rochester in Kent.

It is possible that because of this demotion Dighton was keen to re-establish his position in the excise service. This might explain his enthusiasm to pursue the Coiners and bring them to justice, even though it was not the responsibility of the excise service.

Dighton's demotion was short-lived and the minutes[44] of 6 April 1759 record that he made an appeal to be restored to his former position. Less than a week later, on 12 April 1759, a vacancy became available in Halifax due to reorganisation to accommodate the need for extra staff to cover the collection in Reading. The Excise Board minutes[45] detailed the changes and Dighton's appointment to Halifax.

William Dighton and his family moved to Halifax where he took up his new position. At this time he would have been around forty-two years of age. By 1769, Dighton was married and had seven surviving children: Elias, Thomas, William, John, George, Susannah, and Mary. Of these, Elias and William were apprentices and Thomas had gone to the East Indies. The rest lived with their parents at Bull Close Lane in Halifax. Another daughter, Penelope, had died at the age of eighteen in 1763, four years after the family moved to Halifax.

Through his work, William Dighton would have encountered traders who attempted to pay their taxes with the reduced coins. In his dealings in the Halifax area, he would also have come across the prominent local solicitor Robert Parker. Parker provided the link to the law enforcement authorities that Dighton needed to act against the Coiners. Their partnership became effective swiftly but was due to the introduction of a third party, the informant James Broadbent.

Broadbent had been a soldier for six years until he was discharged, and he now earned a living as a weaver and charcoal burner. He was thought to be on the periphery of David Hartley's gang. According to a statement he made later,[46] Broadbent was approached by Dighton via Joseph Broadbent in the summer of 1769 to assist as a witness against John Sutcliffe, who lodged with his father, John Broadbent. Some weeks later Joseph Broadbent called on him again to assist in arresting Thomas Clayton of Hebden Bridge.

The Coiners' arrests were announced in the local newspapers. Firstly, the *Leeds Mercury*[47] of 19 September 1769 reported that several people suspected of coining had absconded and that John Pickles, James Oldfield and several others had been arrested and sent to York Castle gaol.

Above is a recreation of a handbill circulated on 16 September 1769 announcing the arrest of various people on suspicion of coining including John Sutcliffe, who was supposedly the first coiner to be arrested with the assistance of James Broadbent. John Pickles, who was also mentioned in this handbill, was arrested on more information given by Broadbent.

These early arrests were of gang members who played only a small part in the operations of the gang, but the handbill gives an indication of the number of people suspected of being involved when it talks of 'above one hundred persons' being informed against, with warrants issued against many of them.

To make a significant impact, Dighton wanted the men that sat at the top of the gang and controlled its operations. It was evident from later documents that Dighton knew who these men were and had pressed Broadbent to inform against them.[48] Broadbent finally caved in and on 12 October 1769, he gave a deposition[49] to Justice Edward Leedes in which he claimed to have witnessed David Hartley clip four guineas and James Jagger catch the clippings in a paper.

Armed with this information, Dighton finally had the evidence he needed to arrest the man that he had been keen to apprehend, David Hartley, reputedly the leader of the Coiners gang. Wasting no time Dighton made his move and on 14 October 1769 David Hartley and James Jagger were arrested. Hartley was arrested at The Old Cock in Halifax, with Jagger's arrest at the Cross Pipes on nearby Silver Street occurring simultaneously, so that the men's friends could not warn each other.

The *Leeds* Mercury,[50] on 17 October 1769, announced the arrests of Hartley and Jagger and indicated Hartley's title of 'King David, the leader of the Coiners'.

A week later, on 24 October 1769, the arrest of more Coiners and their associates was announced in the *Leeds* Mercury,[51] including John Pickles' wife, James Shaw who could apparently 'clip and mill a guinea in less than a minute', and Stephen Morton, who were both sent to York gaol. William Roberts of Bacup

Sept 16 1769

C O I N E R S

C O M I T T E D T O

Y O R K C A S T L E

O N S U S P I C I O N

Of Chipping, Filing, Edging and Diminishing the Gold Coin of this Kingdom

ON Wednesday evening the 6th instant, was committed to York Castle, John Pickles, of Wadsworth Banks, Near Halifax, on supicion of diminishing three, guineas and one twenty seven shilling picec of Portugal gold: After he was seized, there were found in his pockets, a pair of scissors, and an instrument for milling the edges of gold pieces. At the time the above delinquent was apprehended, he was manufacturing white pieces, and seemed to leave his looms very reluctantly: He is an elderly man, near sixty, has a wife and a large family, and it is supposed he is an old offender.

Also on Friday last was committed to York Castle, John Sutcliffe of Erringden, in the West Riding, charged with chipping, filing, edging, and diminishing several guineas and a half a guinea.

Also on Saturday last in the eveing ----- Oldfield of Midgeley, was committed to York Castle, for clipping, coining, &c., &c.

Last night in the evening, the wife of John Pickles, commonly called Jack of Matts, alias Jack of Pecket Well, was conducted thro' this town, (Halifax) on her way to York Castle, on horseback, with her hands ty'd, and coining tools in a bag by her side. As she passed thro' the bottom of the town the man who led the hose danced, and the mob hooted her over the bridge. This

woman has been the most noted vendor and procurer in these parts.

At the time she was taken, her husband made his escape, the likewise declared, should her husband be taken and suffer the law, she would, (thro' her information,) hang forty coiners.

This day, several persons of this town and parts adjacent, have absconded, as is supposed for fear of being apprehended.

It is also confidently asserted that there have been above O N E H U N D R E D persons informed of, and that there are now Warrants out against the most considerable of them.

We have now the pleasing satisfaction of seeing the Bands of these formidable set of villains broken: Terror and dismay have taken holden of them, and they no longer dare face the injured public.

Behold Great Turvin, see the Time draw near;
when every Golden Son shall quake with fear;
See Tyburn gorged with protracted Food;
And honoured with the weight of *Royal Blood

* Alluding to some of the C O I N E R S being
 called K I N G S

Recreation of a handbill announcing the arrest of various Coiners.

was also arrested in connection with paying and receiving bad coin and sent to Lancaster gaol.

On 6 November 1769 the arrest of John Barker, who had been informed against by Joseph Shay over six weeks before, was announced in the *Leeds Mercury*.[52] The day after his arrest, Barker gave two separate depositions to Justice Leedes against other men he claimed to have witnessed clipping and edging coins. The first[53]

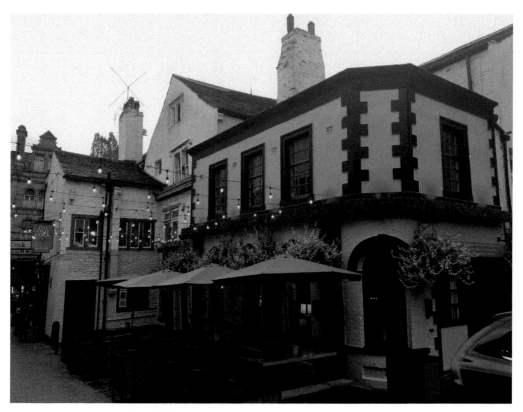

The Old Cock Inn, Halifax, where David Hartley was arrested.

was against Thomas Greenwood who Barker claimed to have witnessed clip two guineas. Barker also gave a deposition[54] against John Parker for the same offence.

William Dighton must have thought the capture of so many Coiners, including their leader King David, would disrupt the Coiners, but within days of these latest events the story took a sinister turn, and the Coiners took their revenge against Dighton.

MURDER PLOT

By early November, the Coiners' leader was imprisoned in York together with several of his gang and awaiting trial at the spring assizes. The effect of the arrest of King David and several of his Coiners had the opposite effect of what Dighton hoped.

It is likely that even before David Hartley was arrested, the Coiners had planned to get rid of the man that threatened their illegal trade. The arrest of their leader quite possibly hastened their actions. As later evidence suggested,[55] meetings were held between Isaac Hartley and other Coiners resulting in an agreement that Dighton must be murdered.

Several Coiners agreed to contribute to a fund that would be paid to the person or persons who would carry out the murder. It emerged later[56] that the following subscriptions had been made:

Abraham Lumb, a farmer of Sowerby – 10 pounds
Luke Dewhurst, of Sowerby – 20 pounds
Jonathon Bolton, of Erringden – 20 pounds
David Hartley (King David) – 20 pounds
Isaac Hartley – would make the sum up to 100 pounds

David Hartley perhaps still had some influence, since his brother would have access to him through the railings between the felons and debtors exercise areas at the York gaol. Records show that Isaac Hartley visited his brother with James Broadbent[57] in the hope of securing David Hartley's release. This would have given the opportunity to discuss the plans for getting rid of Dighton.

The Coiners found two willing men in Robert Thomas and Matthew Normanton and the agreement was made that they would be paid £100 between them to kill William Dighton. Isaac Hartley allegedly agreed to supply the gun that they would use. Thomas, Normanton and a third man, Thomas Spencer, travelled twice to Halifax to carry out their task, but on both occasions they failed to see Dighton.

On their third attempt on the night of 9 November 1769, Thomas and Normanton lay in wait for Dighton near his house. Spencer had chosen to attend the Goose Fair in Mytholmroyd that night so was not present. Dighton had been to a meeting in a Halifax Inn with a colleague, Thomas Sayer, and shortly before midnight he left to make his way home to Bull Close Lane. As he passed by where

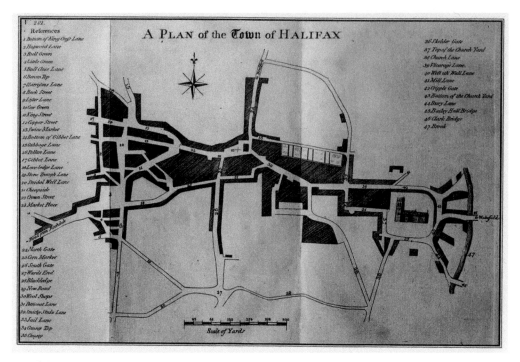

A plan of the town of Halifax in 1759. Bull Close Lane is number five on the far left. (Watson, John, *The History and Antiquities of the Parish of Halifax, in Yorkshire* (Halifax: T. Lowndes, 1775))

the murderers were waiting not far from his home, they aimed and pulled their triggers.

According to later statements, the Blunderbuss of Thomas did not fire, but the pistol used by Normanton did and the lead slug hit Dighton in the head. After he fell to the floor, the two men leapt from their hiding place to check that he was dead. It was also stated that the men stamped on Dighton's body and searched his pockets for money, taking four guineas from the dead man.[58] Satisfied that Dighton was dead the two men made their escape.

The following day, on 10 November 1769, Thomas Sayer, the solicitor with whom William Dighton had met and been drinking with shortly before his murder, made a statement[59] to Thomas Hyde, the Coroner, confirming the details of their meeting. He also confirmed the time they left and walked together as far as Cow Green where they parted.

That same day, a further statement[60] was made to the Coroner by Joseph Gledhill, a neighbour of Dighton who described the discovery of Dighton's body by him, one of Dighton's daughters and Dighton's servant shortly after the gunshots were heard. In his statement Gledhill described the marks that were seen on Dighton's body, including the wound made by the slug from the gun. Gledhill also noted that Dighton appeared to have been struck on the left side of his head, possibly by the butt of a gun, and there was an imprint of a shoe on his chest.

An eighteenth-century blunderbuss, like one of the guns used in the murder.

William Dighton's gravestone in Halifax Parish Church.

A full and true Account

Of a barbarous, bloody, and inhuman

M U R D E R

Committed on the Body of Mr Dighton, Officer of Excise for the Town of Halifax, on Thursday the 9th Day of November, 1769

THE above Mr Dighton had been transacting the business as the day of the 9th November until the evening, when he chanced to be engaged in company pretty late that night; and as near as can be computed it was eleven o'clock before the company broke up; Mr Dighton took leave and bid good night, and went by himself to a place called Bull Close, about a quarter of a mile from Halifax; he had not got above half way, when he was fired upon by some person or persons unknown; they no sooner saw that he fell down, but, it is supposed, they rushed upon him and stamped upon his breast until he was quite dead, as a person declared who helped to lay him out, that the marks was visible upon his breast of the nails of their shoes, he was seen to have between nine and ten guineas in his pockets, which these villains, after they had committed this horrid crime, took from him. It is thought they watched him so narrowly the same evening, that they knew the house he was engaged in, and the exact time the company broke up; it is likewise thought, that the place where he was shot, the muzzle of the peice was not three yards from him; upon viewing the place where he was shot, it is supposed they concealed themselves in a corner of the field near a gate that led into the lane where Mr Dighton was to pass in his way home, and upon this gate they levelled their piece, as the marks of the flash are to be seen on both staves of the gate.

Great numbers of people flock daily to the place where he was shot, who are all astonished at the barbarity of mankind, and especially in the unfortunate Mr Dighton, who had surprisingly industrious in finding out and taking up part of a gang of villains, who are connected together in bodies, in different parts of the country, and carry out their illicit trade of clipping and coining the current coin of this kingdom. Pity it is then that this gentleman should be so suddenly cut off; he had struck such terror amongst them, that they resolved to kill him, thinking to reign unmolested; but we hope his place will soon be supply'd, and a sharp look out after the offenders, who we make no doubt will soon be took, and meet with a punishment adequate to their reward.

We have just received the following account concerning the murder of Mr Dighton, through the information of one Jame Broadbent, of Mytholmroyd Bridge, who has been in custody some time, and declares the abovesaid Robert Thomas to be the person who murdered Mr Dighton; proper persons were immediately dispatched who took him in is house in Wadworth Banks, Near Hebden Bridge, and conveyed him to Halifax; they likewise brought a pair of shoes, with the heels full of large nails; it is supposed after he was shot he was stamped upon, as the marks were visible on his breast.

The above Robert Thomas has a wife and four children in a very poor and distressed condition, but since the murder of Mr Dighton, he has a load of meal, a large quantity of beef, malt, &c. &c. which it is supposed he bought with the money he robbed Mr Dighton of after he was murdered.

This day, (the 19th) two more persons were taken up on suspicion of being concerned in the above murder, more are hourly expected.

After the examination of James Broadbent, the Jury summed up the evidence, and gave it as their opinion that Robert Thomas, Matthew Normanton, and William Folds were either the persons abbettors, or assistancers, in the murder of Mr William Dighton, Gentleman, whereupon the Coroner comiited them to York Castle, to take up their trials at the next Assize.

Recreation of a handbill giving an account of Dighton's murder.

William Dighton was buried at Halifax Parish Church on 11 November 1769. Tragically, his murder had been carried out six years to the day from the death of his daughter Penelope, who had died on 9 November 1763. The gravestone, which can still be seen in the east cross aisle of Halifax Parish Church, records the burial of Penelope Dighton and her father, William.

Ironically the first person arrested on suspicion of the murder was the man who had been helping Dighton: the informant James Broadbent. He was arrested only a few days after the murder.

8

GATHERING EVIDENCE

James Broadbent gave a lengthy statement[61] to the Coroner on 13 November 1769 shortly before his arrest, which gave comprehensive details of the work he had been undertaking for Dighton, including his part in assisting some of the early arrests of the Coiners. It also detailed the circumstances leading to Hartley and Jagger's arrests, and showed that on several occasions, Dighton had asked Broadbent whether he was able to inform against Jagger and Hartley.

The statement indicated that following Jagger and Hartley's arrests, several people, including Isaac Hartley, pressed Broadbent to withdraw his evidence against them and to confirm their innocence of the charges they faced. This resulted in him travelling to York, accompanied by his father and Isaac Hartley. On another occasion after being pressed further, Broadbent claimed to have travelled to Milford, to meet with Mr Leedes, the Justice with whom Broadbent had laid his original evidence against Jagger and Hartley.

Broadbent's statement also gave an account of his whereabouts at the time of the murder and claimed that he was at his lodgings resting after returning from Milford and York a second time. It then continued to describe how he only found out about the murder the following day.

This was the first of several statements that James Broadbent gave at various times concerning the murder. Critically though, Broadbent changed his account of events surrounding the murder in each statement, which did not help those pursuing Dighton's murderers to secure an early conviction.

Another statement[62] was made to the Coroner on 13 November 1769 by Barbara Broadbent, the wife of an innkeeper in Mytholmroyd, who kept the public house commonly known as Barbary's which the Coiners used regularly. This showed that the witness had seen James Broadbent on the Thursday before the murder and supported his claim that he had been tired and wanted to rest.

But Mr Hyde also took a separate statement[63] on 13 November 1769 from Thomas Greenwood, Martha Eagland's landlord, which gave conflicting evidence about where James Broadbent was on the night of the murder. Greenwood stated that according to Mary Eagland, Martha Eagland's daughter, Broadbent had not stayed at her house as he had claimed. It is possible that this statement cast sufficient doubt on Broadbent's account of his whereabouts to arouse suspicion that he had been involved in the murder, which resulted in him being arrested.

News of Dighton's murder was published in the *Leeds Intelligencer*[64] on 14 November 1769 and the Coiners gang was suspected immediately. The report

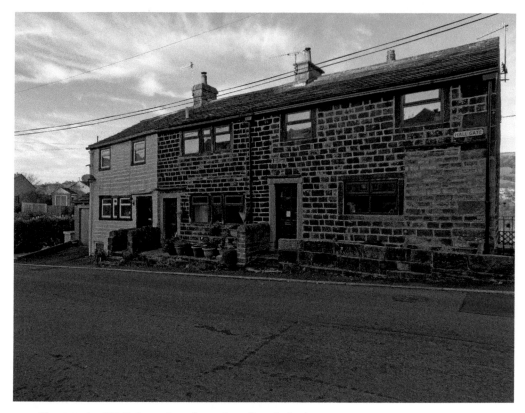

Photograph of Hall Gate where James Broadbent lodged.

indicated that Dighton was stabbed after being shot, but evidence from the surgeon who examined Dighton's body confirmed[65] the report was not true.

The murder of the excise man was described more accurately in the *Leeds Mercury*,[66] also on 14 November 1769 and confirmed that Dighton had been shot in the head, robbed, and his body stamped on. Once again, the Coiners were accused of his murder due to his involvement in their pursuit. The same issue of the *Leeds Mercury* continued with the announcement of the arrest of George Thompson from the area who had been arrested in Newcastle for clipping gold coins.

Meanwhile the Excise Office reorganised its officers to cover the vacant post left by Dighton's murder. As it had done when Dighton had been demoted in 1758, various supervisors were relocated, and examiners promoted to supervisors. The new supervisor in Halifax was George Thompson as the Customs minute book[67] recorded on 14 November 1769, only five days after Dighton's murder.

News of Dighton's murder now reached Parliament and roused the attention of Lord Weymouth. Thomas Thynne, 3rd Viscount Weymouth at this time, held the cabinet position of the Secretary of State for the Southern Department. Of the two British Secretaries of State at the time, this was the most senior position, and he was responsible for southern England, Wales, Ireland, the American colonies (until 1768) and relations with the Roman Catholic and Muslim states of Europe.

Thomas Thynne, from an engraving *c.* 1795 by James Heath and Sir Thomas Lawrence.
(© National Portrait Gallery)

Lord Weymouth wrote immediately to Lord Rockingham calling upon his assistance to apprehend the murderers and stop the practice of coining in the area. Charles Watson-Wentworth, 2nd Marquis of Rockingham had been First Lord of the Treasury (Prime Minister) and Leader of the House of Lords between July 1765 and July 1766 and now sat on the opposition benches. With his family home at Wentworth Woodhouse near Rotherham, Rockingham was the First Lieutenant of Yorkshire and took a keen interest in the affairs of his county. Rockingham played a key role in mobilising the authorities to act against the Coiners, which would eventually bring many of them to justice and put an end to the practice of coining in the area.

Weymouth's letter[68] to Rockingham on 14 November 1769 detailed the activities of the Coiners around Halifax and explained that Dighton had acted to have them arrested but had been murdered by the gang as a result. Weymouth had therefore discussed this with the King and his Majesty had agreed to advertise a reward of £100 for information leading to the murderer, with a pardon to all but the murderer.

The advertisement referred to in Weymouth's letter was published in the *London Gazette*[69] in its issue number 10992 of 14 to 18 November 1769. When the advert was published in the *Leeds Mercury*[70] on 28 November 1769 it included an additional clause offered by the gentlemen and merchants of Halifax which doubled the reward.

James Broadbent's next action was to attempt to divert the attention away from himself and possibly hope to secure the reward, so on Saturday 18 November 1769 he named the three men he believed had been responsible for the murder. Matthew Normanton, Robert Thomas, and William Folds were arrested the following day on 19 November 1769.

Matthew Normanton and Robert Thomas gave statements to the Coroner the day after their arrest to account for their whereabouts on the day of Dighton's murder. The two men's statements generally supported each other, and each man confirmed that they were in Halifax on the day of the murder.

Matthew Normanton gave his statement[71] to the Coroner on 20 November 1769 and said that he had been in Halifax in the late afternoon drinking. He had met Robert Thomas in the early evening, and they had more drinks together and left around eight o'clock to walk home and parted near Newland Gate. He denied being near the area that Dighton was murdered and said he knew nothing of the murder until the Saturday afterwards.

Robert Thomas's statement,[72] which was also made on 20 November 1769, confirmed that he had been in Halifax on the day of Dighton's murder and supported the details that Normanton had given regarding their meeting and the timing of their movements.

On 20 November 1769, two further statements were taken by the Coroner. Both statements confirmed that Thomas and Normanton were in Halifax on the day of the murder. The first statement[73] from Grace Lister, the wife of Joshua Lister, an innkeeper in Halifax, confirmed that Matthew Normanton had been drinking alone in her husband's inn on the afternoon of 9 November.

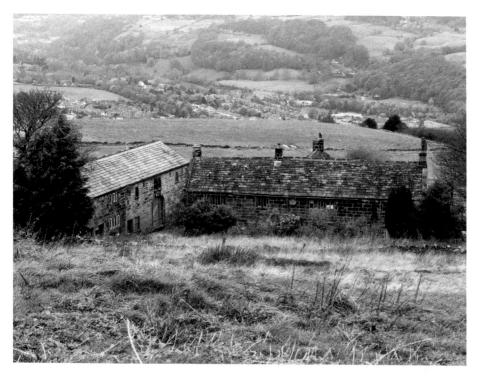

Photograph of Stannery End, the home of Matthew Normanton.

The second statement[74] from Martha Shaw, the wife of Joshua Shaw, another Halifax innkeeper, confirmed that by early evening on 9 November, Thomas and Normanton had met up and were drinking in another public house in Halifax, just as both men had stated in their examinations.

The arrest of the three men that had been named by Broadbent in connection with Dighton's murder was reported in the *Leeds Mercury*[75] on 21 November 1769 and noted that the shoes one of the men was wearing had nails with large heads driven into them, with a suggestion that it was the same boots that had been used to stamp on Dighton's body.

The additional arrests were also described in the *Leeds Intelligencer*[76] of the same date. The report suggested that the motivation behind Broadbent's naming of the three suspects was the attraction of the rewards and the pardon that had been published previously.

The same day as these articles were published in the newspapers, the surgeon that had examined Dighton's body on two occasions following his murder gave a statement[77] to the Coroner detailing his findings. This confirmed that the wound made by the lead slug behind Dighton's ear was the cause of his death. Jonathon Oldfield also noted during his examination that there was another wound on the head and that the breast showed signs of being violently compressed. This supported the claim that Dighton had been struck on the head and stamped upon or kicked by his assailants after he had been shot.

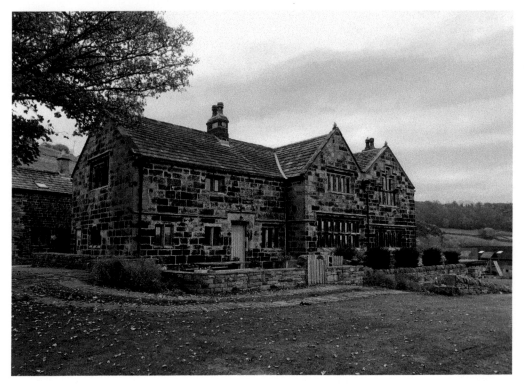

Birchen Lee Carr, Wadsworth Banks – the home of Robert Thomas.

9

JUSTICES ACT

The pursuit of the Coiners gang increased its pace, led principally by local solicitor Robert Parker, but with the support of the Marquis of Rockingham.

Evidence of the number of people that were suspected of coining came in the form of a proclamation in which the names and descriptions of the wanted men were published. The proclamation confirmed that at a meeting held in Bradford on 22 November 1769, the gentlemen present agreed that all means necessary should be used to bring the Coiners to justice and a reward of 10 guineas would be offered for each arrest.

John Royds, one of the men present at the meeting, a merchant banker and trader born in Soyland who lived at Royds House,[78] wrote to Lord Rockingham to inform him of some of the developments in Halifax following Dighton's murder and some details of the meeting in Bradford. His letter[79] of 24 November 1769 also gave an indication that Justice Leedes had made an application to the government for militia to be despatched to Halifax. The latter part of his letter also described the destitute situation that Dighton's widow now found herself in. Royds indicated that for the time being the gentlemen of Halifax were assisting financially, but he pleaded for financial support from the government.

The proclamation[80] resulting from the meeting in Bradford was issued on 25 November 1769 and described in detail many of the men who had previously been informed against in the depositions earlier in this book. This proclamation was then printed in the newspapers, including the *Leeds Intelligencer* and *Leeds Mercury*, each week. Other names would be added to the list in March 1770.

On the same date as the proclamation was published, Lord Rockingham responded[81] to John Royds' letter, thanking him for the information it contained relative to the arrests resulting from Broadbent's information. He continued in his letter to suggest that he should travel to Halifax to express his gratitude for the actions of the local gentlemen directly and to show his support to the local Justices of the Peace, and perhaps encourage others to act.

Rockingham also signified his agreement with the suggestion that Dighton's widow should be provided for as they had been left with no money since the murder. He sent a contribution himself with his letter to assist her in her poor state.

He commented on the request for military intervention and suggested that whilst it might provide some temporary assurance to the neighbourhood, the assurance

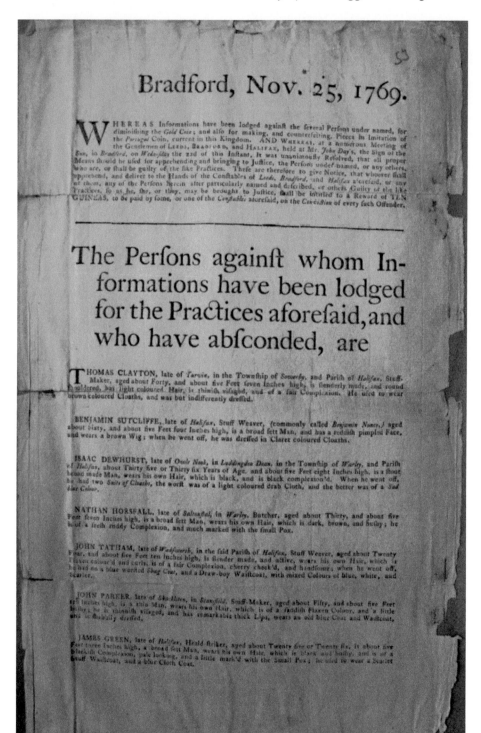

A copy of 25 November proclamation in the Halifax Archives.

would be gone when the troops were withdrawn. Rockingham expressed a preference for the local law enforcement authorities to be given support to carry out their duties effectively, which would draw a longer-lasting effect and cited a similar case in Sheffield previously where the civil powers had been supported rather than troops being deployed to some effect. Rockingham sent his servant to deliver the letter to John Royds and to await his reply, which Royds did later that night.

Royds' response[82] written late in the evening indicated that he was encouraged by Rockingham's suggestion of a visit to Halifax and pleaded with him to be his guest rather than stay at a local inn. He acknowledged Rockingham's comments that the troops might not be required and in order that the request could be cancelled if necessary, he had instructed Rockingham's servant to set out early the following morning with the response. Royds concluded that he looked forward to receiving Rockingham as his guest on the Monday and warned that the condition of the roads between Wentworth Woodhouse and Halifax might make the journey long.

Prompted by Royds' positive response, Rockingham called on the support of the Justices of the Peace and distinguished gentlemen throughout the West Riding of Yorkshire, to act to bring the practice of coining to an end. On 26 November 1769, he wrote a circular letter[83] requesting them to attend a meeting in Halifax on the following Tuesday. Rockingham indicated that one of his primary reasons for attending was to encourage support for the Justices of the Peace in the area and to persuade others to take up a temporary commission of the peace. Rockingham travelled to stay with John Royds in Halifax to be present at the meeting and was welcomed into the town to the sound of a peal of Bells rung at the parish church.

During all this official activity, more information was still coming to light from people willing to make depositions against Coiners. On 27 November 1769 Joseph Shaw made a statement[84] against Isaac Dewhirst and John Cockroft for clipping coins and making half moidores from the melted-down clippings.

The meeting called by Rockingham was held at the Talbot Inn in Halifax on 28 November 1769. Several resolutions were carried at the meeting which were recorded[85] together with the list of those that attended. The agreements made included calling on the support of the gentlemen present to the justices for discovering and apprehending the Coiners, that Dighton's widow should be provided with financial support, and that Lord Rockingham be thanked for his attention to the situation and for attending the meeting.

Several of the names contained in the list of attendees appear regularly in this book due to the part that many of them played in the story of the Coiners. Besides Rockingham, the meeting was attended by Henry Wickham, who had taken many of the depositions; Richard Wilson, the Recorder of Leeds who corresponded on several occasions; John Royds, with whom Rockingham stayed during his visit; Thomas Sayer, who had met with Dighton the night of his murder; and Robert Parker, the solicitor who would assist with the prosecutions of many of the Coiners and Dighton's murderers.

Photograph of the microfiche copy of the meeting at the Talbot Inn.

On the day of the meeting, 28 November 1769, the *Leeds Mercury*[86] published more information about the arrest of James Broadbent, Robert Thomas, Matthew Normanton, and William Folds on suspicion of Dighton's murder and their journey through Leeds on their way to York. The *Leeds Intelligencer*[87] then included a brief note in its issue of 28 November 1769 which recorded the meeting of Lord Rockingham with the Gentlemen of Halifax and the hopes that it might result in bringing the Coiners to justice.

10

GOVERNMENT CORRESPONDENCE

After the meeting in Halifax, Rockingham returned home and, on 1 December 1769, he wrote a lengthy letter[88] to Lord Weymouth, in which he explained the outcome of the meeting. Rockingham also called upon Lord Weymouth to ensure that Dighton's widow and children were provided for by Mrs Dighton receiving an annual allowance and support for apprenticeships for the younger children.

He referred to the letter that had been sent from Altena on 6 October 1767 and the case of John Greenwood, which was the first mention of coining activities in the area, suggesting that if it could be found it might contain information that would lead to several arrests. Rockingham complained that the mint solicitor had already been provided with information on several occasions, but it had not been pursued. He indicated that the solicitor had not acted as 'his salary did not allow him to carry on prosecutions'. Rockingham suggested that officers of the Royal Mint should become involved as they would be best placed to identify evidence of clipping and coining during searches.

He then relayed the story of the two men, Crabtree and Haley, who had been working for Samuel Lister and John Stanhope. He mentioned that a warrant had been issued for the arrest of one of the men but that it had since been withdrawn. Rockingham indicated that he was taking steps to ensure the men's real intentions were understood by the law enforcement authorities locally so that no further action was taken against them.

Finally, Rockingham indicated that the opinion of the meeting was to carry out an immediate trial of those in custody rather than wait for the assizes, so that some speedy executions might serve as an example to others. Rockingham had discouraged this and indicated that waiting until the assizes might result in many more arrests with a greater impact.

Perhaps the rewards that were now being offered encouraged false accusations, because on 5 December 1769, the *Leeds Mercury*[89] published an advertisement by Thomas Gomersall, a licensed victualler, who viciously denied the claims set against him and offered a reward of 5 guineas for proof of who had encouraged the accusations.

On 5 December 1769, Weymouth responded[90] to Rockingham's letter, which acknowledged the measures taken at the meeting of the Justices and Gentlemen and indicated that these met with the King's approval. Weymouth also confirmed that the letter sent from Mr Woodford in Altena was being searched for. He then indicated in his postscript that it had not been located and that whilst Mr Woodford had been approached and was clearly familiar with the case of John Greenwood, he did not recall ever writing such a letter.

Charles Watson-Wentworth (Lord Rockingham), *c.* 1768, by Sir Joshua Reynolds. (© National Portrait Gallery)

Weymouth also wrote to the Treasury on 5 December 1769, enclosing the letter from Lord Rockingham and indicated the King's approval to act against the Coiners. Weymouth called on the support of the Treasury to bring the coining activities to an end without delay.

On 6 December 1769, Rockingham wrote[91] to Weymouth with details of William Dighton's children, listing their ages and whether they were employed, apprenticed or still at home. Rockingham also enclosed a letter[92] from John Hustler which

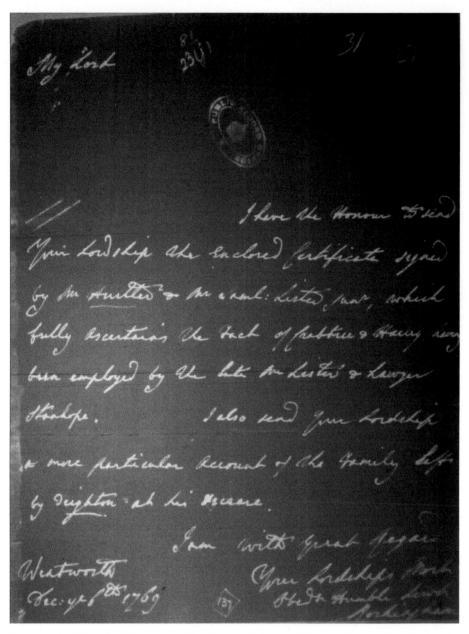

Photograph of the microfiche copy of Rockingham's letter to Weymouth on 6 December 1769.

confirmed that William Haley and James Crabtree had been employed by Stanhope and Lister to detect and inform against Coiners. Hustler's letter[93] also consisted of a certificate signed by Sam Lister and John Hustler which offered the two men protection against prosecution for the crimes they had been employed to detect.

The Treasury responded to Lord Weymouth on 7 December 1769, with a letter[94] from Grey Cooper, the senior secretary to the Treasury, which confirmed that in

accordance with Rockingham's wishes, the Mint Solicitor and another officer would be sent to Halifax.

The Treasury Board was the main decision-making body in the Treasury and up until 1827 was attended by the Prime Minster as First Lord of the Treasury, with the Chancellor of the Exchequer as Second Lord, and other Junior Lords. The decisions of the Treasury Board were recorded in the *Fair Minutes*. The entry in the minute book[95] for 7 December 1769 listed those present at the meeting as the Duke of Grafton,[96] Lord North,[97] and Charles Jenkinson.[98] The minute recorded that Lord Rockingham's letter of 6 December 1769 had been received via Lord Weymouth and read by the Treasury Board. It then recorded the decisions taken by the Board, which included responding to Lord Weymouth to acknowledge his letter and indicated that the content had been considered and that the Board agreed that officers of the Mint should be sent to Halifax to assist with the detection and prosecution of the Coiners. The end of the letter confirmed that William Chamberlayne, the Solicitor to the Mint, had been ordered to attend the Treasury Board meeting the following day.

A copy of the Treasury Board minute[99] entered on 8 December 1769 was enclosed with Cooper's letter and confirmed the directions given to William Chamberlayne by the Treasury Board. The full minute entered into the minute book also confirmed that if the regular annual allowance for carrying out prosecutions against Coiners was insufficient, the Treasury Board would support the application of additional funds as necessary, and that Lord Weymouth should be informed that Chamberlayne would be in Halifax by the following Tuesday. The final note of the minute also indicated that the annual allowance available to the Mint Solicitor for carrying out prosecutions was to be reconsidered by the Treasury Board the same day as Chamberlayne was due to arrive in Halifax.

In accordance with this minute Grey Cooper wrote[100] to Robert Wood, under Secretary to Lord Weymouth, and asked Wood to inform Lord Weymouth that the Mint Solicitor, Mr Chamberlayne, would be travelling to Halifax. On 9 December 1769, Grey Cooper wrote[101] to Lord Rockingham to confirm that the order had been given for William Chamberlayne to be sent to Halifax and to take with him a moneyer who would be able to assist in detecting Coiners and clippers. Cooper also confirmed that Dighton's widow was to receive £50 per annum and be provided with £200 for her children to be apprenticed.

As suggested by Grey Cooper in his letter, Lord Weymouth wrote to Lord Rockingham on 9 December 1769 to confirm that William Chamberlayne had been directed to go to Halifax. Weymouth also asked Rockingham to correspond directly with the Treasury rather than through him to avoid any delay and indicated that there was little more he himself could do.

The same day, Robert Wood wrote to Grey Cooper enclosing the letter referred to in Weymouth's letter which confirmed that William Haley and James Crabtree had been employed by Stanhope and Lister to infiltrate the Coiners and that they would now be placed under Lord Rockingham's protection.

The letter from Wood[102] of 9 December 1769 also enclosed the extracts from Ralph Woodford's letters regarding the case of John Greenwood in Hamburg, and indicates that Wood had spoken to Woodford who could not give any further information than the letters contained. Wood also acknowledged the Treasury minute which recorded that William Chamberlayne had been despatched to Halifax. Like Weymouth had done before, he also informed Cooper that the Treasury should now deal directly with those concerned.

Then on 11 December 1769 Thomas Bradshaw, one of the junior secretaries of the Treasury, wrote[103] to Robert Wood and confirmed that Rockingham's request for a pension for Mrs Dighton of £50 per annum and a sum of £200 for funding the apprenticeship of the remaining children would be met.

On 12 December 1769, Grey Cooper wrote to Lord Rockingham[104] and enclosed the extracts of Ralph Woodford's correspondence regarding John Greenwood[105] and had been mentioned by Rockingham in previous letters. Cooper also confirmed that copies of these extracts along with the certificate from John Hustler concerning James Crabtree had been sent to William Chamberlayne who was by now in Halifax.

Despite his earlier letter which stated any further correspondence on the matter would be made directly between the Treasury and Lord Rockingham, Lord Weymouth wrote a further letter[106] on 12 December 1769 to Rockingham. Weymouth wanted to convey the news to Rockingham directly that the King had agreed to grant an annual pension of £50 to Dighton's widow and £200 for apprenticing her children.

The involvement of John Royds continued, and on 13 December 1769, he gave a brief update to Lord Rockingham[107] on the situation in Halifax. He made several suggestions as to how the clippers and Coiners could be discouraged, including the offer of a pardon to those willing to inform against others, and the refusal by the collectors of excise to accept light coin. Royds also reported the arrival in Halifax of William Chamberlayne and Mr Sage from the Mint and noted that Chamberlayne was an old acquaintance of his.

The letter also indicated the preparation of a proclamation, based on some clauses from acts of Parliament relating to the rewards and pardons available to those who assisted in bringing about the conviction of clippers and Coiners.

In the final paragraph of the letter, Royds mentioned an incident in Heptonstall where a gun had been discharged to kill a man. Fortunately, the gunman missed his target, who then managed to catch the gunman. It transpired that the gunman had mistaken the identity of the man and was released when the target realised that he knew him and two other men that had been with the gunman.

A proclamation was published by William Chamberlayne on his arrival in Halifax, on 14 December 1769. The proclamation offered a royal pardon to any person convicted of coining who then informs against two or more people, and included a provision for any person still in apprenticeship to be declared a freeman, able to continue in trade as though he had served the full term of his apprenticeship. The proclamation also offered a reward of £40 for every person the information convicts, based on an Act of Parliament[108] passed during the reign of King William III. A footnote on the proclamation promised another 10 guineas

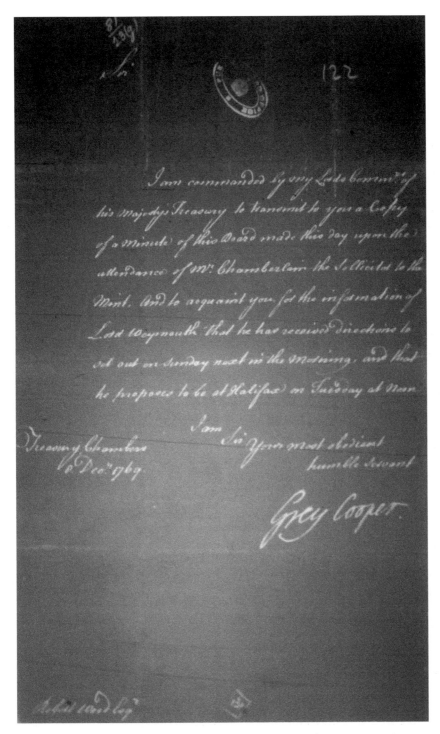

Photograph of the microfiche copy in the Sheffield Archives of Grey Cooper's letter to Robert Wood.

WHEREAS the Practice of Clipping the Gold Coin of this Kingdom hath for a considerable Time last past been carried on in the Parish of Halifax, and Towns adjacent, and in divers other Places within the West-Riding of the County of York,

AND WHEREAS there is great Reason to believe, that numbers of Persons have been drawn in to the Commission of the said Offence, not knowing at the Time, that by the Laws of this Realm, the same is declared to be HIGH TREASON, and afterwards having come to the Knowledge of the Consequence of their Offence, have nevertheless continued in the Practice thereof, from an Apprehension that they could not make a Discovery without convicting themselves; It is therefore thought proper to give this PUBLIC NOTICE, That by an Act of Parliament past in the Seventh Year of the Reign of his late Majesty KING WILLIAM the THIRD, any Person guilty of Clipping or Diminishing, or Coining the Current Coin of this Realm, who shall afterwards Discover two or more Persons who have committed either of the said Crimes and give Information thereof to any One of his Majesty's Justices of the Peace, so as Two or more be convicted of the same, is thereby declared intitled to his Majesty's Pardon for all his said Crimes which he may have committed before such Discovery, and if such Person be an Apprentice, he is thereby declared to be a Freeman, and hath thereby Liberty to Exercise any lawful Trade, Profession, or Mystery, with all Liberties and Priviledges, and in as full and ample Manner as if he had served the full Time of his Apprenticeship, and is moreover by the said Act intitled to the Reward of FORTY POUNDS for every Person convicted.

WM. CHAMBERLAYNE,

Solliciter to his Majesty's Mint

WHITE LION, HALIFAX,
14th DECEMBER, 1769.

N. B. The Towns of *Halifax*, *Leeds*, and *Bradford*. have offered a Reward of TEN GUINEAS for every Person convicted, over and above the Reward allowed by Act of Parliament.

Copy of a handbill announcing the rewards for information in the Halifax Archives.

over and above the £40 from the local townships for each person convicted. It was hoped that this offer of a pardon and a reward would tempt those already in custody to try and secure their release and a reward by informing against others.

John Sutcliffe, who was one of the first men to be committed to York Castle, therefore made a deposition[109] on 14 December 1770 in which he claimed he had witnessed John Cockroft, Luke Dewhirst, John Dewhurst and Peter Barker clip coins at various times.

The same day on 14 December 1769, Stephen Morton, who had been committed to York Castle shortly after Sutcliffe, made a deposition[110] which accused Matthew Normanton, William Clayton and Thomas Clayton of clipping coins and Isaac Hartley and George Ewbank of buying the clippings.

William Chamberlayne acknowledged receipt of the information sent via John Royds on 16 December 1769[111] and gave a general update on his initial findings. He indicated his disappointment that the evidence gathered so far against the Coiners was unlikely to secure convictions as it was generally one man accusing another, without any supporting evidence. Chamberlayne then said he would attempt to secure such evidence himself whilst he was there but thought it would be unlikely given the heightened state of alarm locally.

At one point in his letter Chamberlayne gave an indication that he was not surprised by the temptation for 'the poor men' to clip good guineas, due to the general acceptance of guineas that were light in weight. Chamberlayne continued and suggested that the practice of clipping and coining had continued due to an acceptance of the light and counterfeit coin by the collectors of Excise and Land Tax. He suggested that if they were given orders to refuse such coins the circulation would be substantially reduced.

11

FURTHER ARRESTS

On 19 December 1769, the *Leeds Mercury*[112] published a note indicating that due to a shortage of magistrates in the West Riding, several local gentlemen had taken up positions to assist the Justices of the Peace.

The newspaper on the same day also reported further arrests of people suspected of coining, with Thomas and Daniel Greenwood of Wadsworth Banks arrested and sent to York Castle gaol. Another man, John Cockroft, had absconded from the Halifax area but had been arrested in Darlington. The paper reported that upwards of thirty people from the county were now in gaol on suspicion of clipping or coining.

On 20 December 1769, the day after being named in this article as being arrested on suspicion of coining, John Cockroft was examined[113] and indicated that he had been shown how to clip coins by John Ibbetson. He said that Ibbetson had told him he could teach him how to 'live without work' by making Portuguese coins.

John Royds wrote again to Lord Rockingham and included a note about the confession of Cockroft and indicated that because of him implicating four other people, two of them had been committed to gaol in York.

The remainder of his letter[114] dated 20 December 1769 detailed the progress made by William Chamberlayne and Mr Sage and that several warrants had been issued by the local Justices to search houses for coining tools or arrest suspects.

Royds also confirmed that William Chamberlayne had travelled to Rochdale with him to meet with Richard Townley who had also been involved in trying to bring the Coiners to justice.

The same day, Thomas Bradshaw, the Junior Secretary to the Treasury, wrote to Lord Rockingham to confirm that the money that the King had granted would be provided to apprentice Dighton's children had been passed on to him and was ready to be paid to wherever Rockingham decided.

The *Leeds Mercury*[115] of 21 December 1769 announced the arrests of more suspects, some of whom were named in Cockroft's examination. The men arrested were John Bates, Jonas Tillotson, Thomas Wilson, and Thomas Westerman, and all were sent to York gaol.

Thomas Westerman was examined[116] on 21 December 1769 and stated that he had seen several people including Cockroft clipping coins at various times and supported Cockroft's description of John Bates using dies to produce counterfeit Portuguese coins.

Westerman also claimed to have witnessed William Harper and John Spencer clip gold coins, so they were examined[117] on 21 December 1769 by Henry Wickham.

In what was now becoming a regular pattern they provided a counteraccusation against Westerman stating that they had witnessed him clip a coin. They also claimed to have witnessed Thomas Wilson clip a coin in John Cockroft's house.

Daniel Greenwood, whose arrest had been announced in the *Leeds Mercury* on 19 December, was also examined on 21 December 1769.

This time the examination was made by Francis Topham, and Greenwood stated that he and Simeon Greenwood had witnessed Joshua Lister, Joseph Geldart, and Isaac Dewhirst stamp a coin in a die or mould, then clip and edge it afterwards.

Thomas Wilson, who was apprenticed to John Cockroft, was examined[118] the same day, and gave evidence against Joseph Hanson, John Bates, and his master John Cockroft, stating that he had witnessed the men clipping coins at various times and melt the gold down to make into new coins.

The number of people being named in connection with the activities of the Coiners in such examinations and depositions was growing all the time. Amongst the papers of Robert Parker held in the archives at Halifax is a copy of the list of Coiners that was issued previously on 25 November. On the back of this paper[119] a list of another forty-eight men was added in the handwriting of Robert Parker and indicated that it was taken from an account given by Eli Hoyle on 22 December 1769. Many of the names given in this list have already appeared in the depositions mentioned previously or are men that have themselves made depositions against others.

On 24 December 1769 Joshua Stancliffe, a watchmaker from Halifax, made a deposition[120] to Henry Wickham. In this statement he described the method that the Coiners employed to launder their clipped coins in return for bills of exchange and he named Samuel Magson as being involved in the process.

Stancliffe also described the involvement of James Oldfield and David Hartley in collecting clipped gold and providing coining tools. He also said that Brian Dempsey and Joseph Hanson had at various times offered him coins to clip.

Then at the end of his statement, Stancliffe indicated that Isaac Hartley had visited him shortly before William Dighton's murder and suggested that Dighton would not live to see the assizes and had possibly already escaped an attempt on his life.

The following day on 25 December 1769, Stancliffe provided further information[121] which named Thomas Sunderland as the supplier of the dies used by the Coiners. He also confirmed that a set of milling tools he had handed to Robert Parker were the ones he had received from David Hartley. This evidence given against David Hartley by Stancliffe would ultimately be used as evidence in Hartley's prosecution.

In the examination of Thomas Westerman, Thomas Stansfield had been described as assisting John Cockroft as he clipped coins. Westerman claimed to have witnessed Stansfield file the edges of the coins after Cockroft had clipped them. Now on 25 December 1769, Stansfield gave his account[122] of his involvement with Cockroft.

He also claimed to have witnessed some of the other people named by Westerman as being involved in the act of clipping, including William Harper and John Spencer who had previously been arrested and examined.

It is interesting to note that the beginning of Stansfield's examination indicated that he was 'in custody but not in jail'. It seems from this and some of the subsequent examinations that Coiners were still being arrested but were no longer being transported to York Castle.

By this time twenty-two Coiners had been recorded as being arrested and imprisoned either in Lancaster Castle, York Castle or in one instance in Newgate, Newcastle.

On 25 December 1769, the same day as Stansfield gave his information, Samuel Magson, who had been named in Joshua Stancliffe's information, was also examined. In his statement[123] Magson described how he had been told by David Hartley '(commonly called King David)' that he could make money by clipping gold off coins as they passed through his hands. David Hartley had then shown Magson how to clip a coin using common scissors and edge the coin afterwards with a file. Magson then described how he sold the clippings he subsequently took off coins to Hartley and was paid in counterfeit Portuguese moidores which Magson firmly believed were made by Hartley.

Magson continued his examination and stated that he had also been involved with James Oldfield who sold him gold and clippings which Magson then sold to Joshua Stancliffe and another watchmaker in London.

Magson then described the circumstances around a set of dies produced by Thomas Sunderland, an engraver, which were evidently of a poor standard and not accepted by the man that had ordered them, William Crabtree.

At the end of his examination Magson made an interesting statement where he suggested that James Oldfield somehow continued the practice of clipping coins even whilst he was in custody in Halifax gaol.

The next deposition came from Jonas Tillotson who is once more recorded as being in custody but not in prison despite the *Leeds Mercury* on 21 December 1769 reporting him as being transported through Leeds on his way to York Castle.

In his deposition[124] Tillotson described how he was introduced to coining by John Bates, the innkeeper of the Wheat Sheaf in Halifax who had been named in the same newspaper report as being transported with Tillotson.

Tillotson went on to explain that he had been in York Castle as a debtor, which perhaps explained the reason he was described as in custody but not in prison.

Remarkably Tillotson admitted to using a 'new' moidore provided by Bates to pay Robert Parker. Not surprisingly Parker was reluctant to take the coin but did so, perhaps to keep as evidence.

Then on 26 December 1769, an advertisement appeared in the *Leeds Mercury*[125] indicating that even those expected to uphold the law had themselves been drawn into the unlawful activities of the Coiners.

Joseph Hanson was an innkeeper, first named as being connected with coining activities in the deposition of Thomas Westerman on 21 December 1769 and subsequently in information provided by the watchmaker Joshua Stancliffe. Hanson also fulfilled another role as Deputy Constable of Halifax. Perhaps this was how James Oldfield managed to continue the practice of clipping guineas even whilst in Halifax gaol, as suggested by Samuel Magson.

The *Leeds Mercury* on the same date also announced that the King had granted a bounty of £100 to Dighton's widow and an annual pension of £50 per annum.

Having already made various depositions and accusations against Coiners, Joshua Stancliffe was himself accused of coining activities by Brian Dempsey who was examined[126] on 27 December 1769. As a merchant, Dempsey had access to large sums of cash which he could also change for bills of exchange, so he was useful to the Coiners as a means of providing new, full-weight coin, possibly from outside the region, which the Coiners could then clip and recirculate through Dempsey.

As an indication of the value of money involved, Dempsey claimed that Stancliffe had on one occasion asked to borrow a sum of £300 and regularly for smaller sums of 20 to 30 guineas. Dempsey also mentioned that Samuel Magson, another Coiner, had asked to be lent money in the same way and had paid for the money he borrowed with his own bills.

On 28 December 1769, Adam Liley gave a short statement[127] against Daniel Greenwood, Paul Taylor and John Wilcock and claimed to have witnessed Greenwood and Taylor clip several gold coins at Wilcock's house.

The same day, Lord Rockingham wrote[128] to the Treasury to update them briefly on the progress made in Halifax and informed them that William Chamberlayne was on his way back to London and would be able to give greater detail than he could. Rockingham feared they had not yet got to the bottom of the problem but that there was great support from the gentlemen of the area to continue the pursuit.

Towards the end of his letter, Rockingham indicated that Chamberlayne had suggested that the government should direct the Excise Officers to refuse to take diminished coins. Rockingham thought that this may help locally, but that it could force a wholesale recoinage across the kingdom which would prove difficult and expensive. However, he did confirm that several of the local gentlemen had agreed not to accept diminished coins.

The final deposition[129] of 1769 was made on 30 December 1769 by William Crabtree, who claimed to have seen James Oldfield with a set of Coiners' dies. Crabtree also claimed that Oldfield had asked him to sell the dies for him, but that Crabtree had refused. Oldfield had later asked Crabtree to sell some gold clippings but again Crabtree had refused.

12

NEW YEAR, NEW ACCUSATIONS

The first deposition of the new year was made by John Kitson on 1 January 1770 against James and Daniel Greene and several of their associates. His account[130] also described a place known as the 'Halifax Mint' which was apparently run by father and son William and Thomas Varley.

Kitson described in detail how the scissors, crucibles and dies used by this pair were stored secretly around their property. He then described how he had seen the pair of men collect these tools at various times and use them to weigh gold, then mould and stamp coins from clippings supplied by others.

The same day another man, Robert Iredale, gave a similar statement[131] against Thomas Sunderland in which he described another method used by some Coiners, by increasing the value of lower-denomination coins.

The Debtors' Prison at York Castle where the Coiners were held.

Iredale described how he had seen Sunderland heat up some low-denomination gold coins in the fire before stamping the softened coins with a set of dies to give them the appearance of a higher-value coin. Iredale went on to describe how he had witnessed Sunderland clip coins provided by James Hill on other occasions. He also described several others who had been involved in clipping or stamping coins, including William Varley, whose house was again referred to as the 'Halifax Mint'.

The arrest of Coiners continued into the New Year and on 2 January 1770 the *Leeds Mercury*[132] reported several arrests of Coiners in Bradford, some of whom were also from the Halifax and Turvin area. They were named as Thomas Stansfield, John Crossley and his son, William Harpur, John Spencer, Paul Taylor, and Daniel Greenwood. The newspaper on this date also reported the escape of William Hartley, 'commonly called Duke of Edinburgh', as the Constables attempted to arrest him, by creeping out of a window wearing only a shirt.

The subject of the Coiners was raised again on 2 January 1770 by the Treasury Board when the Board read and considered the content of letters[133] from William Chamberlayne and Lord Rockingham.

The members of the Treasury Board appeared to have difficulty with enforcing Chamberlayne's suggestion that orders should be given that the collectors of Land Tax or Excise to refuse any light or counterfeit coins, and to cut any such coins that were offered in payment.

The *Leeds Mercury*[134] published a proclamation on 2 January 1770 which reminded the newpaper's readers of the provision made previously by the government in the Coin Act of 1696.[135] This reinforced the powers for the Justices and Constable to search premises where the occupants were suspected of coining activities. It also reiterated the provisions made for pardon and rewards indicated on the notice published previously.

On 3 January 1770, two days after the deposition by Robert Iredale, Thomas Sunderland, who had been named in Iredale's information, gave his own information to Henry Wickham. In his information[136] Sunderland followed the normal pattern of accusing others of clipping coins with no mention of his own participation other than being asked to make a set of dies, which he said he couldn't do.

On the same day, Daniel Green, who had also been named in Iredale's information, gave a deposition[137] to Francis Topham which supported Iredale's claims regarding William Varley making counterfeit coins.

Likewise, George Ramsden also gave information[138] to Henry Wickham, again on the 3 January 1770, which gave further evidence of William Varley's activities and detailed several transactions that had been made to allow Varley and his son to clip gold coins. As a result of the information given by Iredale, Green and Ramsden, William Varley and his son Thomas were examined on 4 January 1770 by Henry Wickham.

In his examination[139] Thomas Varley described how Joseph Gelder had come to their house and asked William Varley to help him melt down some clippings which they then made into half moidore coins. He went on to describe a few visits

to his father's house by Robert Iredale, Thomas Sunderland, John Bates, James Green, John Kitson, William Haworth and George Ramsden, all of whom took part in either clipping gold coins or making new coins using clippings from gold coins which they brought with them.

William Varley was then examined[140] and repeated almost the same information as his son, but claimed that rather than being involved in the act he was usually an unwilling witness to the activities of those who visited his house, even being threatened with his life on one occasion by Robert Iredale and James Green.

In an expression of thanks to Lord Rockingham, the Gentlemen of Halifax sent a note[141] dated 6 January 1770. This acknowledged Rockingham's involvement in the events in Halifax and thanked him for keeping them informed of progress by providing copies of correspondence between Rockingham and the Treasury. The note also expressed their thanks for the support shown to Dighton's widow and the effect that William Chamberlayne and Mr Sage from the Mint had on their arrival. Finally, the note supported the earlier suggestion of refusing to accept light or counterfeit coins that had been described in John Royds' letter of 13 December 1769.

Further evidence regarding the ways of the Coiners and those involved came to light all the time. One such account came from an innkeeper called John Bates[142] which described how he became involved in coining, some of the people he became involved with and how the coining was carried out using scissors and files.

He described how he had seen the Coiners melt the gold in a small pot in the fire then pour it into a piece of brass with a round hole in it, before beating it with a hammer to the rough size of a coin. The Coiners then uses their spelter[143] stamps to hammer the impression of a coin onto the faces.

Bates also included some detail on the manufacture of the Coiners' spelter dies that were used to stamp out the counterfeit coins and how he himself acquired a set of 'coining irons'. He indicated that David Hartley's dies were made by a man called Lighthoulers. In this evidence, Bates suggested that it was David Hartley that first brought coining to the area, having learned how to coin in Birmingham.

His affidavit[144] was forwarded (though it is not apparent who to) by Mint Solicitor William Chamberlayne on 6 January 1770. Chamberlayne had underscored several names and sections of the affidavit in relation to suspects he had not yet heard of.

More evidence against Thomas Sunderland came from James Shaw, who was examined[145] on 10 January 1770 and stated that at various times he had witnessed Sunderland clip and file coins and make new half and quarter moidores using a pair of dies, assisted at times by John Ibbetson.

Shaw also gave information against David Hartley in his examination and stated that he had been asked to take clippings to Hartley to be made into new coins, which he said Hartley had made new Portuguese coins from.

On 12 January 1770 Richard Townley sent a letter to Lord Rockingham which gave further acknowledgement of Rockingham's involvement in the actions taken in Halifax. Townley's letter indicated that the practice of coining had stretched over the county border and was also occurring in Lancashire, resulting in information coming forward (which he copied to Rockingham) and several committals. As

well as offering his services to support the legal authorities in Yorkshire, Townley suggested that the solution to bringing the Coiners to justice was by encouraging informers by means of reward and pardon.

The Treasury Board minute book on 23 January 1770 indicated that in response to the request made by the board on 2 January to prevent the circulation of the clipped coins, the collectors of Excise in Yorkshire had been instructed to co-operate locally.

On 25 January 1770, Robert Barker gave an account[146] to William Lamplugh of his involvement on the periphery of coining activities. He was apparently engaged by several Coiners in passing off diminished coins and obtaining large coins for clipping, for which he was generally recompensed. Barker also mentioned being shown a set of Coiners' dies on one occasion by Abraham Lumb, which could be used to make moidores.

John Cockroft gave information[147] against Joseph Shay and his son-in-law Jonathon Barrowclough on 30 January 1770, in which he claimed to have visited Shaw's house where it was evident the two men had been producing a counterfeit coin. He also stated in his information that on another occasion, Barrowclough had asked to borrow a set of dice since his were no longer any good, and that at other times Barrowclough had claimed to have clipped coins and made new coins from the clippings.

As a result of the information provided by Cockroft, Jonathon Barrowclough was examined[148] by Henry Wickham on 3 February 1770. His lengthy statement denied any involvement in coining and indicated that he was rather more an unwilling witness to his father-in-law's activities.

He went on to describe how, after witnessing his father-in-law and Thomas Sunderland 'bargaining' over a set of coining dies, he protested to them and threatened to inform the local Constable. After he set off to the Constable's house, he claimed to have been followed by Sunderland and James Shaw and that the men threatened to kill him with a long knife that Sunderland carried. Barrowclough described how he sought sanctuary at a nearby house before escaping later and hiding out under a hedge near his own home, unable to return because Sunderland and Shaw were waiting there for him.

He claimed to have seen Shaw, Sunderland and another man, John Ibbetson, a few days later and that they abducted him and held him prisoner overnight in a room at Shaw's public house. He said he was released only after they had twice made him kneel and swear that he would not inform on them.

In the latter part of his examination Barrowclough described the various people that met with his father-in-law and either clipped coins or made new coins with his assistance. Throughout his examination, Barrowclough claimed to have taken no part in the act of coining.

On 3 February 1770, information[149] was also provided by Joseph Shaw, who had previously given a lengthy statement on 27 November 1769. This time Shaw claimed to have witnessed several people clipping and stamping coins at various times, including Isaac Dewhirst, Thomas Barker, Joseph Murgatroyd, Thomas Sunderland, James Shay, John Bates, Joshua and Lydia Brigg, and John Ibbetson.

It is apparent from the information provided by Shaw that Isaac Dewhirst was quite active in the production of counterfeit coins, either by clipping coins himself or melting down clippings provided by others and 'making up' new coins.

Henry Shaw, most likely a relative of Joseph Shaw, also gave information[150] on 3 February 1770 which backed up the latter part of Joseph Shaw's information and claimed to have witnessed Joshua Brigg file and edge gold coins.

A list of the prisoners who are to take their trials this assizes, at York, on Saturday the 24th of March, 1770, before the right honourable William, Lord Mansfield and Sir Henry Gold, Knight.

Sir BELLINGHAM GRAHAM, Bart, High Sheriff.

JOHN SUTCLIFFE, late of Erringden, charged upon the oath of Joseph Broadbent, Weaver, for that he, the said John Sutcliffe, did impair, diminish and lighten several guineas, and half guineas, the current coin of this realm.

John Pickles, of Wadsworth, charged upon oath that he the said John Pickles, did at the parish of Halifax, clip, file, and lighten three pieces of gold, of the current coin of this realm, called guineas, and also one other piece of gold called a Moidore.

Stephen Morton of Stainland, charged upon oath by William Haley, of Horton, and James Crabtree of Halifax, with clipping, filing and diminishing thirteen guineas, or otherwise for employing persons to do so.

James Oldfield, of Warley, charged upon oath by James Crabtree of Halifax, and William Haley, of Horton, with clipping, filing and diminishing twelve guineas and two thirty six shillings pieces, and two twenty seven shillings pieces, Portugal gold, current in this kingdom.

David Heartley, of Erringden, charged upon oath, for clipping and diminishing four pieces of gold coin, called guineas.

James Jagger, of Erringden, charged upon oath with the suspicion of clipping and diminishing several pieces of gold called guineas.

Thomas Waid, otherwise Wade, of Midgley charged upon oath of clipping and diminishing several pieces of gold called guineas.

John Barker, of the parish of Halifax, carpenter, charged upon oath, that the said John Barker did lately bring to one Isaac Dewhurst, at the parish of Halifax aforesaid, a quantity of gold clippings, and desired him, the said Isaac Dewhurst, to make them for him, the said John Barker into seven and twenty shillings pieces: And that the said Isaac Dewhurst being lame, delivered his puncheon or dye to him the said John Barker; and the said John Barker struck the impression of a seven and twenty shilling piece, on several pieces of gold, which he had melted out of the said gold clippings, and edged them with a file to resemble Moidores.

Robert Thomas, Matthew Normanton, William Folds, and James Broadbent. The said Robert Thomas charged with the wilful murder of William Dighton, Gentleman; and the said Matthew Normanton, William Folds and James Broadbent, charged with being present, aiding, helping, assisting and maintaining the said Robert Thomas, in committing the said murder.

John Cockroft, late of Leeds, charged upon oath for being guilty of bringing a quantity of gold clippings to one Isaac Dewhurst, to be made into a thirteen shillings and sixpence piece of gold.

Thomas Greenwood, of Wadsworth, charged upon suspicion of diminishing two pieces of gold coin, called guineas.

Jonas Tillotson, of Ovenden, charged upon the oath of Robert Walsh, on suspicion of high treason, in diminishing the gold coin, called guineas, half guineas, and quarter guineas.

John Bates, of Halifax, charged upon the oath of Jonas Tillotson, with being guilty of diminishing the gold coin, called guineas.

Thomas Westerman, of Leeds, Woolcomber, charged upon oath with diminishing the gold coin, called guineas.

Thomas Wilson, of Northowram, charged upon oath with clipping and diminishing guineas.

Thomas Stansfield, charged upon oath by Thomas Westerman, on suspicion of clipping and diminishing guineas, and other gold coin.

John Crosley, charged upon the oath by Thomas Westerman, on suspicion of clipping guineas.

Abraham Crosley, charged upon the oath by Thomas Westerman, on suspicion of clipping guineas.

John Spencer, charged upon oath with clipping guineas, and other gold coin.

William Harper, for clipping, filing &c.

Daniel Greenwood, charged upon oath by Adam Liley, on suspicion of diminishing guineas, and other gold coin.

Paul Taylor, charged upon oath by Adam Liley, on suspicion of clipping guineas &c.

William Varley, of Warley, charged upon oath by John Kitson, for diminishing guineas, and making dies and other implements for stamping of gold.

Thomas Varley, of Warley, charged upon oath by John Kitson, for clipping guineas and other gold coin of this realm.

Ely Hill of Barkisland, charged upon oath by Thomas Sunderland, for clipping and diminishing guineas, and other gold coin.

John Hill, charged upon oath by Thomas Sunderland, for clipping guineas and other coin.

Luke Dewhurst, charged upon oath by John Sutcliffe, late of Erringden, that he saw the said Luke Dewhurst, clip, file, lighten, and diminish three pieces of gold coin, called guineas; and the said John Sutcliffe saw the said Luke Dewhurst stamp or coin one piece of gold, called a Moidore; and also he saw at the same time in the custody of the said Luke Dewhurst, several small plates of gold, as he supposed calculated for the purpose of coining

Recreation of a handbill with details of those charged with coining.

The following day, on 4 February 1770, Valentyne Smythes gave information[151] against Abraham Lumb and John Dewhurst, who were both apparently buying guineas for more than they were worth, generally giving an extra shilling for each guinea they bought.

A day later, 5 February 1770, information[152] was given by Adam Liley against Robert Wade, John Wilcock and John Thomas, who Liley claimed between them gathered gold, clipped it and passed it back into circulation.

With the spring assizes just over a month away the final information[153] against Coiners came on 6 February 1770 from Martha Westwood, who claimed to have seen James Green clip, file and edge a guinea and collect the clippings.

The 6 February 1770 also saw the announcement in the *Leeds Mercury*[154] of the final arrest of Luke Dewhurst before the spring assizes started. By this time, James Broadbent had been in custody in York for about four months and he made a further statement[155] on 18 February 1770 about Dighton's murder. In a change to his previous statement, he claimed he had been in Halifax at the time of the murder and had been stationed a little way further down the lane from where the murder was committed. He claimed that he witnessed the murder and Thomas and Normanton abusing and robbing Dighton's body afterwards.

13

THE SPRING ASSIZES

The handbill recreated previously lists those prisoners that would be tried during the 1770 spring assizes and the charges they each faced. It is interesting to note how many facing charges themselves had informed against others, perhaps in the hope of securing their release and a pardon as promised by the proclamations made to date.

The pursuit of the Coiners continued though, and several names and descriptions were now added to the list of suspects that had been published weekly in the newspapers until now. The additional descriptions first appeared in the *Leeds Intelligencer*[156] in its issue of 20 March 1770. The new names added to the list were Peter Barker, William Clayton, John Ibbetson, Matthew Hepworth, Joseph Hanson, Isaac Hartley, John Wilcock, Joshua Lister, Joseph Gelder and Joshua Shaw.

The spring assizes started on Saturday 24 March 1770 before William Murray, 1st Earl of Mansfield, Lord Chief Justice of the King's Bench and Sir Henry Gould, one of the Justices of his Majesty's Court of Common Pleas. The High Sheriff was Sir Bellingham Graham, 5th Baronet of Norton Conyers.

As Lord Chief Justice, William Murray (Lord Mansfield) was the second highest Judge of the Courts of England and Wales, after the Lord Chancellor. Murray was married to Elizabeth Finch, whose sister Mary was married to Thomas Watson-Wentworth, the 1st Marquess of Rockingham, so making Murray Lord Rockingham's uncle.

Murray's involvement in the trial of the Coiners at these assizes alongside the regular circuit judges such as Sir Henry Gould gives an indication of the high profile of the trials and the importance of securing convictions.

Sixty-four felons faced their trials at the spring assizes, of which thirty-one were either Coiners or suspected of the murder of William Dighton. Other felons at the assizes faced charges of sheep or horse stealing, theft, burglary and murder.

A total of seventy-two jurors were sworn in for the duration of the assizes and it is interesting to note that none were from any of the areas surrounding Halifax. In fact, most of the jurors were from places in East and North Yorkshire.

The *Leeds Intelligencer*[157] announced the start of the spring assizes with Justice Gould in its issue of 27 March 1770, and amongst the details of all the felons facing trial it listed those accused of coining offences, followed by the list of men who would face their trial for the murder of William Dighton.

The start of the spring assizes was reported similarly in the *Leeds Mercury*[158] of the same date, which also confirmed that the assizes were being attended by Lord Chief Justice Lord Mansfield, and Sir Henry Gould, one of the Justices of the Court of Common Pleas.

William Murray, 1st Earl of Mansfield, exhibited in 1783 by John Singleton Copley. (© National Portrait Gallery)

Sir Henry Gould published in 1794 by Thomas Hardy and Hugh Richards. (© National Portrait Gallery)

The first trial of Coiners was that of William Varley and his son Thomas on Saturday 31 March 1770. Both men faced two charges of coining before Justice Gould.

The Crown and Civil minute books for the Northern and North-Eastern circuit assizes record the verdicts reached at the assizes. For each case these record the names of the jurors and the verdict against the charge.

The minute book[159] indicated that William Varley was found guilty of forging a guinea on 10 April 1769 and again on 12 April 1769. Thomas Varley was thought to have been influenced by his father and was found not guilty.

Another entry in the minute book[160] recorded the verdict against James Oldfield, who had been discovered through the efforts of James Crabtree and William Haley working for Samuel Lister and John Stanhope. He was tried the same day as the Varleys for forging a guinea on 10 September 1769 and found guilty by the same jury.

The following days consisted of various trials of people accused of burglary, stealing goods, and receiving stolen goods. Most defendants were either found not guilty or had fines or short prison sentences imposed.

The trial of David Hartley was held on Tuesday 2 April 1770. The main evidence was provided by Broadbent, whose statement to the Coroner on 13 November

1769 said that he had seen Hartley clip four guineas. He claimed he had witnessed James Jagger collecting the clippings with a piece of paper.

Evidence had also been provided against David Hartley by the watchmaker Joshua Stancliffe, innkeeper John Bates and by James Shaw.

The record in the minute book described the guilty verdict against David Hartley for forging a guinea.

On Wednesday 3 April 1770, the remaining Coiners were bailed to appear at the next assizes. The minute book recorded the names of the defendants and the bail and surety amounts. These details were also recorded in a letter from Robert Parker on 18 April 1770.

The trial against Thomas, Normanton, Folds and Broadbent did not proceed at this time and though there is no record in the minute book, the four men were ordered to remain in gaol until the next Assizes.[161]

On 3 April 1770, the *Leeds Mercury*[162] announced the verdicts of the trials against the Varleys and Oldfield. By the time the newspaper was printed the news of the other verdicts had not reached the printers.

Following his conviction, David Hartley made a statement[163] on 5 April 1770 which indicated that he had made enquiries about the murder of William Dighton in the weeks leading up to his trial.

Hartley suggested that James Broadbent and William Folds were not involved in the murder and that Robert Thomas and Matthew Normanton were the only

Photograph of David Hartley's affidavit in the Halifax Archives.

people who had been involved. He also suggested that his brother Isaac Hartley had provided this information and that more might come to light soon afterwards.

Perhaps based on this potential evidence coming forward, William Chamberlayne saw an opportunity to strengthen the case against Dighton's murderers who, on the evidence to date, stood a good chance of being set free. Chamberlayne was therefore keen to delay their trial until better evidence was available which might therefore be sufficient to convict the men.

An affidavit[164] was also made by William Chamberlayne before Justice Gould on the 5 April 1770 which indicated that the reason the trial of these men was postponed was because the murder was committed at night and there was a lack of evidence, but that better evidence might be available by the next assizes.

In its issue a week later, on 10 April 1770, the Leeds Mercury[165] was able to report the outcome of all the various trials against the Coiners, listing David Hartley, James Oldfield and William Varley as being sentenced to death, with the remainder of those accused of coining bailed to appear at the autumn assizes.

The newspaper also recorded that Robert Thomas, Matthew Normanton, William Folds and James Broadbent, all accused of being involved in Dighton's murder, had been ordered to remain in gaol until the next assizes.

Likewise, the Leeds Intelligencer[166] also detailed the verdicts against the Coiners and delay to the trial of the suspected murderers in its issue of 10 April 1770. The newspaper indicated that although a total of thirteen people had been sentenced to death for various crimes during the assizes, it was only the three convicted Coiners that would be hanged at that time, with the remaining ten non-Coiners having a reprieve till the next assizes.

Shortly after his conviction, James Oldfield, who had been sentenced to be executed, had a plea for him to be pardoned circulated at the highest levels. A petition and several letters in Oldfield's favour, including a letter from the Earl of Dartmouth, were sent with a letter from Lord Rockingham to Lord Weymouth.

Weymouth responded with a letter[167] to Justice Gould on 16 April 1770 enclosing copies of the various letters and asking the Justice to consider whether Oldfield might be shown mercy by royal pardon.

The names of all of those charged at the spring assizes that were bailed to appear at the autumn assizes were requested in a letter[168] by Robert Parker on 18 April 1770. In the letter, Parker also wrote that the charges against William Crabtree would be discharged as there was no charge against him. Parker also requested 'capias warrants'[169] against the absconders Thomas Clayton, John Ibbetson, Joseph Gelder, Joshua Lister, Benjamin Sutcliffe, William Clayton, James Green and Joseph Hanson so that they could be arrested prior to the autumn assizes.

The response was appended to the same document the same day and listed each of the men released on bail and the amount to be paid by their sureties if the accused failed to appear.

It is evident that attempts to deter witnesses from giving evidence were still going on and one such case of intimidation was detailed in a notice published in the London Gazette in issue number 11037 from 24 to 28 April 1770. This detailed a letter that had been left in the shutters of the shop window of Joshua Stancliffe, the watchmaker from Halifax.

Stancliffe had acted as a witness against David Hartley and was also expected to give evidence against those accused of William Dighton's murder. The anonymous writer suggested that there was a threat to Stancliffe's life because of the evidence he gave against David Hartley. The letter warned Stancliffe that there were at least a dozen people who wanted him dead if David Hartley was hanged. The notice indicated that his Majesty would grant a pardon to anyone that could help discover who wrote the letter, with a reward of 50 pounds on conviction of any of the offenders.

Regardless, the sentencing of David Hartley was complete, and the execution was to go ahead, so on 28 April 1770, David Hartley was executed at the Tyburn near York. Despite the petition and letters that Lord Rockingham had sent to Lord Weymouth and the King's indication that Oldfield's life should be spared, James Oldfield was also executed alongside David Hartley.

William Varley, who was also due to be executed, had his sentence respited till his Majesty's pleasure.

The executions were recorded in the *Criminal Chronology of York Castle* for 28 April 1770 as follows:

Saturday, April 28th, A.D. 1770 – David Hartley and James Oldfield were convicted, on the oath of James Crabtree and others, of Halifax, for impairing, diminishing and lightening Guineas. They were detected at Halifax, and died penitent, acknowledging the justice of the sentence passed upon them.

The *Leeds Mercury*[170] on 1 May 1770 reported the execution of the two men and indicated that a report that they might have had a chance of a reprieve was not true.

David Hartley's wife, Grace, made a request for her husband's body to be released for burial in the churchyard of St Thomas a Beckett, Heptonstall. Most sources report that as the cart carrying David Hartley's coffin made its way along the Calder Valley, the streets were lined with spectators paying their respects to their local sovereign. On 1 May 1770, David Hartley was laid to rest a short distance from the porch.

The Latin entry in the parish register read: '1770 May 1, David Heartley, di Bell House in Villa Erringdininsis suspensus in collo propé Eboracum ob Nummos publicos illicite cudendos et accidendos.' (David Hartley of Bell House in the township of Erringden, hanged by the neck near York for unlawfully stamping and clipping public coin.) The inscription on the gravestone simply reads 'David Hartley 1770'.

Barely over three weeks after David Hartley was buried at Heptonstall his widow and his brothers became involved in providing evidence against one of David Hartley's closest associates.

David Greenwood was supposedly one of the first to be recruited by the Hartleys and one of their closest associates. He lived at Hill Top Farm, not far from Bell House, and was supposed to have acted as an unofficial solicitor to the Coiners.

As later evidence suggested,[171] Greenwood attempted to bribe Grace Hartley shortly after David Hartley's execution, apparently in payment for representing

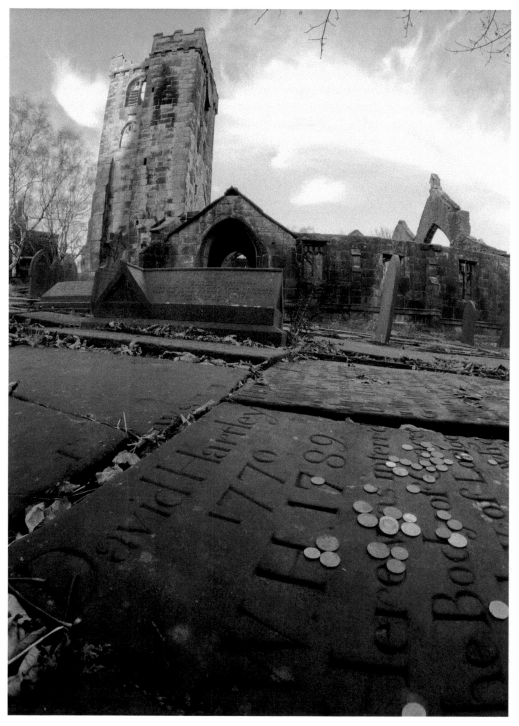

Heptonstall churchyard. David Hartley's grave is in the foreground.

King David at his trial. On 25 May 1770, Grace Hartley was bound over[172] to the sum of £50 to appear at the autumn assizes to give evidence against Greenwood.

William Varley, who had been sentenced to death alongside David Hartley and James Oldfield but had his sentence reprieved at the time, was subsequently granted a free pardon by his majesty King George III on 5 June 1770.

Then a few weeks after Grace Hartley had been bound to give evidence against David Greenwood, David Hartley's brother Isaac made a deposition[173] on 11 June 1770 against Greenwood and alleged that Greenwood had asked David Hartley to help clip a few gold coins in a room at Greenwood's house.

Isaac Hartley claimed to have been present and described how Greenwood said he had to leave part way through the process, so he asked David Hartley to complete the clipping and edging. (Isaac Hartley was called to re-swear his original deposition on the 31 July 1770.)

On the same day, Isaac Hartley and his father, William, were bound over, as Grace Hartley had been, to appear at the autumn assizes to the sum of £50 each. In this new information[174] Greenwood was again accused of clipping and filing gold coins. Isaac and William Hartley also accused Greenwood of making counterfeit silver and gold coins using dies.

When Greenwood himself was examined[175] the same day and asked to plead against the accusation of clipping coins and having dies in his possession by the two Hartleys, he pleaded not guilty. Greenwood would face the charges formally a few weeks later when the autumn assizes began in York.

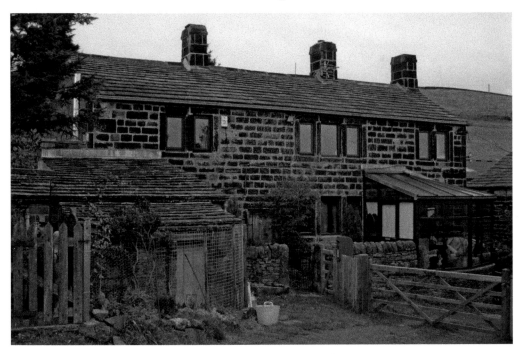

Photograph of Hill Top Farm, the home of David Greenwood.

14

THE AUTUMN ASSIZES

The start of the autumn assizes came on 4 August 1770, when those that had not been tried in spring would face their charges in court. Several of the suspects described in the lists that had been published in the newspapers now had proclamations made against them to surrender and face prosecution at the autumn assizes.

The first of two such documents[176] recorded that John Sutcliffe, Thomas Clayton, John Ibbetson, Joseph Gelder, Joshua Lister, Benjamin Sutcliffe, William Clayton, James Green and Joseph Hanson had fled and had been indicted to appear at the autumn assizes. As none of them had indicated an intention to surrender, a request was made for them to be gaoled or bailed to appear at the next assizes.

The second document[177] was an appeal to the men to surrender to the Sheriff so that they may face the charges laid against them.

Many of the men now being sought were those listed in the descriptions that were added to the original list of suspects in March 1770 because of the various depositions made in the latter part of 1769 and early 1770.

Another brief[178] requested by Mr Chamberlayne was that of David Greenwood, who had appeared before a magistrate in Halifax in June 1769 charged with coining offences. Now he faced several charges based on the information given by David Hartley's brother Isaac and his father, William Hartley.

The brief gave an interesting insight into the relationship between David Greenwood and the Hartleys and indicated that since the execution of David Hartley, the relationship had turned to one of bitterness. The notes suggest that the two Hartleys were no better than Greenwood and it had been suggested they had an involvement in Dighton's murder.

The main trial at the autumn assizes was that of the men accused of Dighton's murder. Broadbent, Thomas, Normanton and Folds were still in custody in York gaol and would now face the charge of murder.

The brief[179] that was prepared for their prosecution indicated a great deal of detail about the methods of the Coiners and how much was known about them. It set out the background to the state of the coin and the activities of the Coiners, who diminished it. It continued to say that the local merchants had complained that the diminished coin was not payable elsewhere. It noted that as the Collector of Excise, Dighton had also felt the effects of the Coiners, so had become active in detecting the offenders, hiring James Broadbent to assist him.

The brief suggested that David Hartley, being one of the most notorious offenders, was a primary target for Dighton to apprehend and Dighton had pressed Broadbent to give evidence against Hartley, which he finally did, resulting in Hartley and Jagger's arrests.

The brief described how, after Dighton and Broadbent and others had escorted Hartley and Jagger to York, Dighton had made a payment to Broadbent. When he returned, Hartley's brothers and friends challenged Broadbent, and he admitted that the evidence he had given was false and he had been induced to give information against them by Dighton.

With this information, the gang pressed Broadbent to withdraw his information in the hope that David Hartley would be set free, but Mr Leedes, the Magistrate, would not accept this. Broadbent was then pressed to write to Dighton to arrange to go with him to the Magistrate, but Dighton ignored the letter, reminding Broadbent that if he perjured himself, Dighton would have no more involvement with him.

As a result of their failure to release David Hartley the Coiners resolved to murder Dighton and hired Thomas and Normanton to carry out the murder. It suggested that Thomas and Normanton engaged Broadbent and Folds to assist.

The brief then described the events of the fateful night, with Dighton's movements from his meeting with Mr Sayer and his walk home towards Bull Close Lane where he was shot. It detailed his injuries from the slug entering his head, and the marks on his body from being trampled and kicked.

Then it described the discovery of Dighton's body by his servant and a neighbour. It indicated that Broadbent was suspected as being involved in the murder and apprehended the following day, after which he gave information on the other three men, though it suggested there was some doubt about Folds' involvement.

The support to the brief was a variety of statements from several different witnesses. These were included within the proofs and included two different statements from James Broadbent. Other statements came from the Coroner, Thomas Sayer, Surgeon Jonathon Oldfield, Dighton's neighbours Joseph Gledhill and William Brearley, and Sheriff's officer Joshua Jones, who arrested Thomas (and discovered a pair of boots with rose headed nails).

Further statements were detailed by Grace Lister, Martha Shaw and Alexander Kershaw who confirmed the movements of Thomas and Normanton. William Dickenson claimed Broadbent had told him that Thomas, Normanton and Folds had asked him to help in the murder and that a new Supervisor would be needed in two or three days.

Other statements were included in the proofs from Isaac Hartley, Joshua Stancliffe, David Greenwood, and from the murder suspects themselves, Thomas, Normanton and Folds.

The proofs then picked out the contradictions between the various statements and examined the claims made, to prove that the statements were false.

The start of the autumn assizes was announced in the newpapers once more and were published on 7 August 1770 by the *Leeds Intelligencer*[180] and indicated that the prisoners that faced trial were Robert Thomas, Matthew Normanton and James Broadbent, on suspicion of murdering Dighton.

When the trial took place, the case against Robert Thomas and Matthew Normanton could not be proved and remarkably both men were acquitted. William Folds was also dismissed as it was recognised he had no part to play in the murder and it was unlikely that he was even in Halifax on the day of the crime.

The minute book[181] on Friday 10 August 1770 recorded the not guilty verdict against the men accused of Dighton's murder.

The following day, on Saturday 11 August 1770, David Greenwood was bailed to appear at the next assizes with an indictment against him for fraud. Likewise, the recognizances in treason against those who had been bailed in spring to appear at the autumn assizes were also discharged indicating that all the men fulfilled their obligations to appear but faced no further charges.

The verdict against the men accused of Dighton's murder was reported in the *Leeds Intelligencer*[182] on 14 August 1770.

Remarkably then the murderers escaped prosecution, despite the extensive evidence that appeared to have been compiled against them. Thomas and Normanton were guilty, there should have been no doubt, but with conflicting evidence, the jury had no choice but to acquit the men, giving them the benefit of doubt.

To understand how this could have happened though it is worth breaking the brief down and examining parts of it, to identify some of the inconsistencies between the statements given by the defendants and witnesses that prevented the truth being apparent.

The counsel's own notes part way through the proofs supporting the brief pick out many of the inconsistencies and make suggestions as to how they could be countered during the trial.

The main part of the brief is derived from the statements by James Broadbent. By the time of the autumn assizes he had made three separate statements, and each differed in the account of his whereabouts at the time of the murder.

In the first statement made to the Coroner on 13 November 1769, shortly before his arrest, Broadbent claimed to be at his lodgings at the house of Martha Eagland, resting after his return from York. He claims to have eaten a meal in the evening prepared by Martha Eagland, and that he went back to bed, not rising until the Friday morning.

The same day as the statement was taken from Broadbent by the Coroner, Thomas Greenwood gave a statement which contradicted Broadbent's account. This said that Greenwood had spoken to Mary Eagland the day after the murder, and she had denied seeing Broadbent.

Perhaps therefore in his statement of 18 February 1770, Broadbent changed his account and stated that he had travelled to Halifax on the day of the murder and had witnessed Normanton and Thomas shoot Dighton and then punch and abuse the dying man's body.

He confirmed in this statement that he was placed close enough to the site of the murder and that the night was light enough for him not only to hear the gunshots, but also to see the shooting and the activities afterwards. He also stated that Folds was present and close by at the time of the murder.

In the statement contained within the brief, Broadbent claimed again that he was present at the time of the murder and had been positioned further down the

lane as a lookout, so only heard the blunderbuss discharge. In this statement he did not claim to have witnessed the murder but said that Thomas and Normanton had come to him a few minutes afterwards, when Thomas claimed to have kicked the dead man in the head.

He also claimed once more that Folds had been present, having rode there on a Galloway. Broadbent also said he returned to Martha Eagland's house and was in bed by 2 or 3 o'clock.

In the statement contained in the brief, Broadbent said that Thomas, Normanton and Folds had met him in Mytholmroyd around 5 o'clock that evening and that they travelled to Halifax together. The evidence of Grace Lister and Martha Shaw contradicted this and said that Normanton had been at Lister's public house between 4 and 6 in the evening and Shaw's between 6 and 7 that same evening. No mention is made of Broadbent.

It's not surprising the jury could not decide whether Broadbent was involved in the murder or not, but the various statements do maintain a degree of consistency about Thomas and Normanton being the murderers.

Witness statements confirmed that the two men were in Halifax hours before the murder being committed and the statement by Alexander Kershaw also supported the claim, indicating that Kershaw had seen Normanton travelling to Halifax the afternoon of the murder carrying a short gun.

Normanton and Thomas both admitted being in Halifax on the day of the murder and their statements about their locations and the times matched those of

The supposed site of William Dighton's murder on Bull Close Lane.

Grace Lister and Martha Shaw. Both claimed to have left Halifax around 8 o'clock and walked to Newland Gate, where they parted and made their way home separately. They both indicated that Folds was not with them, with Normanton claiming that he did not even know Folds before they were taken into custody together.

Whilst the proofs to the brief identified some differences between Thomas and Normanton's accounts, these are not related to the events of the afternoon and the evening of the murder and the counsel suggested that this was due to Thomas and Normanton agreeing what they would say beforehand. The differences between the statements were accounted for by the men being asked questions they did not expect, so the two men were not prepared with corresponding answers.

Perhaps the jury were more prepared to accept the accounts of these two men, whose accounts of the day of the murder generally matched, against that of Broadbent who appeared to be a compulsive liar who was desperate to save his own neck.

The main evidence that could have been used to prove Thomas was present was the shoes that were discovered when Thomas was arrested. These had large nails driven into the soles and could have accounted for the marks discovered on Dighton's body and in the area that the killers had laid in wait as reported by Joseph Gledhill and William Brearley. Perhaps these shoes were common at the time and there was insufficient evidence to link Thomas' shoes specifically to the murder.

As to Folds, he claimed to have been at Wood Mill between Hebden Bridge and Todmorden (8 or 9 miles from Halifax) until 10 o'clock on the night of the murder. He said that the witnesses he had produced to prove this at the assizes had changed their account having been 'tampered with', implying they had been pressured to change their evidence. It was noted in the brief that Folds' statement to the Coroner was not recorded in writing.

Some of the statements given by others indicated that Thomas, Normanton and Broadbent knew that Dighton was expected to be killed soon. William Dickenson indicated that Broadbent had suggested this a day or two before the murder, and Isaac Hartley had stated that Normanton and Thomas suggested Dighton would be murdered when he met with them shortly after David Hartley's arrest.

The counsel suggested that most people believed that Isaac Hartley himself had hired Thomas and Normanton to murder Dighton. In support of this, Joshua Stancliffe stated that Isaac Hartley had visited his shop a few days before the murder and suggested that Dighton would be killed.

David Greenwood then claimed that Isaac Hartley had prepared a gun to be used in the murder and had given this to Normanton. He then claimed that the gun had been given back to Hartley and that he had later broken it up and thrown it in the River Calder after hiding it for some time in the root of a bush.

None of this could prove any involvement of those accused of the murder though, or of Hartley's involvement in hiring the murderers. They may have been aware of what was planned but it did not prove that they were involved.

The counsel seemed to recognise this and stated that this information may not have been sufficient to convict the men but hoped that it may be enough to make

them take a defensive stance, so that by challenging them on the inconsistencies between their statements they might have tripped themselves up.

It must have been frustrating to those involved in the prosecution that the men were not found guilty. The evidence within the brief appeared to be sound enough to secure a conviction. But the differences in the accounts of the various men and the inconsistent statements from Broadbent must have been sufficient to cast a shadow of doubt in the minds of the jurors, who were therefore perhaps reluctant to send the men to the gallows on such unreliable evidence.

To the Coiners, it might have felt like a minor victory. The man that had initiated the arrest of their leader and several members of his gang was now dead, and the men that had got rid of him had escaped the clutches of justice and were now free. The Coiners resumed their wicked ways and Dighton would not be the only man to suffer at their hands.

The Coiners probably believed they could carry on as before unhindered, but they underestimated the determination of the men who had taken Dighton's place, principally Robert Parker, who would continue to pursue the Coiners and Dighton's murderers.

15

ANOTHER MURDER AND MORE EVIDENCE

Evidence of the brutality surrounding the Coiners came early in 1771, when news emerged of another murder.

This time the victim was a man who had claimed he knew who had murdered William Dighton and bragged that he intended to inform against them. But his claims were made in the presence of people who either wanted to protect the guilty, or perhaps wished to make an example of this man to others who might be thinking of doing the same.

The shocking circumstances of what happened to this man, Abraham Ingram, were published in the *Leeds Intelligencer*[183] on 8 January 1771. Ingram had been drinking in a public house in Heptonstall and was in the company of people reputed to be Coiners. Ingram claimed to know who had murdered Dighton and said he would give information against him.

This angered those around him, and they threw him down against the fire and thrust his head into it. After heating the tongs, they clamped them around his neck then filled his trousers with burning coals so that he died in agony.

A few weeks later, the *York Courant* on 19 March 1771 announced the arrest of Mary Newall of Heptonstall on the charge of Ingram's murder. Two men also surrendered themselves for the murder: John Greenwood and James Jagger, the latter of whom had faced charges of coining alongside David Hartley at the 1770 spring assizes and had been freed. However, when the three accused faced Mr Justice Gould at the spring assizes in 1771, they were all acquitted.

Shortly after these events, correspondence between the Mint and the Treasury showed that the expenses incurred in pursuit of the Coiners during 1770 had greatly exceeded the £600 limit and the Mint were struggling to recover their additional costs.

On 9 May 1771, Charles Sloane Cadogan, the Master of the Mint, wrote a letter[184] to Secretary Cooper at the Treasury asking that a special warrant be granted to cover the excess expenditure.

The accounts of William Chamberlayne for 1770 gave more detail on the expenditure and indicated that the costs had arisen because of the prosecutions carried at the request of the government by the Mint.

The full accounts detailed all prosecutions carried out across the whole country in 1770. Of the total national cost of £1736 19s 10d, the prosecution of the Coiners in Yorkshire and Lancashire alone amounted to a third of the total cost at £579 6d.

The introduction or memorial[185] of Chamberlayne's accounts indicated that had it not been for the gang of clippers and Coiners in Yorkshire and Lancashire the

expenses would have fallen within the annual allowance as they had in previous years. The accounts are noted as being received on 12 July 1771 and read on 23 July 1771.

In the latter part of 1771, the pursuit of William Dighton's murderers resulted in more evidence coming to light. In September and October, statements were made by Joseph Broadbent and John Sladdin which indicated on both occasions that Robert Thomas and Matthew Normanton had been employed by Isaac Hartley to carry out the murder of the exciseman.

Joseph Broadbent made a statement[186] on 19 September 1771 in which he described the meeting between Isaac Hartley and the murderers at Elphaborough Hall. He went on to describe the events surrounding the murder and afterwards, including the collection of the subscriptions used to pay the murderers and the disposal of the weapons by Isaac Hartley.

Then on 8 October 1771, John Sladdin, who had been named in Joseph Broadbent's statement, made his own statement[187] to Joshua Horton. Like the information given by Joseph Broadbent, Sladdin described the meetings between Isaac Hartley and the murderers and said that he had also been approached to carry out the murder but had declined. He also confirmed the sum of money that was to be paid to the men if they murdered Dighton as 100 guineas. Sladdin went on to describe some events the day after the murder, when Robert Thomas had not denied being involved.

Despite these additional testimonies which backed up statements made by previous informants, Thomas and Normanton had already been tried for murder and acquitted, so under 'double jeopardy' laws they could not be charged with the same offence again.

Those pursuing justice must have been certain that they had the right men and were determined to see them answer to their crimes.

Photograph of Elphaborough Hall, the home of Isaac Hartley.

FURTHER DISCOVERIES

No progress was made towards prosecuting Thomas and Normanton during 1772, but the pursuit of Coiners in general continued and those in authority explored ways of preventing the Coiners circulating their bad money.

The Treasury Board, who at various times had discussed the Coiners in the light of correspondence received by the members of the Board, once more raised the subject on 2 June 1772. The Treasury Board minute[188] of this date recorded that the Board reconsidered the suggestion made previously by William Chamberlayne that it would make some impact if the collectors of Land Tax and Excise were to refuse to accept any clipped coins.

The action on this occasion was that the Attorney and Solicitor General should assess whether the laws that applied to the silver coin at that time could be extended to the gold coin so that the collectors of Excise and Land Tax could then be instructed to refuse bad coins.

The following day, the Treasury Board met again and had received the opinion of the Attorney and Solicitor General on the proposals outlined by William Chamberlayne. The minute[189] in the Treasury Board minute book on 3 June 1772 indicated that it was agreed that the same protection given to silver could be extended to gold, and that William Chamberlayne was then asked to draft a bill to be put before Parliament.

Towards the end of the year, new statements were being made by new informants which indicated that the practice of coining was continuing in the area.

On 9 December 1772, statements were made to two Justices of the Peace by John Barratt and Edmund Sykes[190] (the Constable of Huddersfield) against Joshua Sharp who claimed that Sharp had offered bad coins.

On the same day, Joshua Sharp made his own statement[191] to account for the bad coins he had attempted to pass to the two men. He claimed to have received one from James Whitley and two from 'Royal Clayton' (Thomas Clayton).

It is not apparent whether any charges resulted from these statements, but they do indicate that coins which had been tampered with were still being circulated in the Halifax and Huddersfield area.

An article which subsequently appeared in the *Leeds Mercury*[192] on 29 June 1773 emphasised the number and variety of counterfeit coins now in circulation by publishing detailed descriptions, highlighting some of the faults with the counterfeit coins the Coiners were producing due to flaws in the engraving of their dies.

A few weeks later, a statement[193] from William Sutcliffe indicated that coining had also been continued some distance away in Bingley by a man called James

Milner. The statement made on 3 July 1773 indicated that Milner had met Thomas Greenwood at Barbary's in Mytholmroyd where Greenwood told him he could show him how to make money easily. Greenwood took Milner to his house where he showed him how to clip and edge gold coins using a pair of scissors and a file.

Based on this information Colonel Townley issued a warrant for Milner's house to be searched but nothing was found. Milner then admitted to selling Greenwood some clippings that he had taken off some guineas.

A warrant was issued to arrest Greenwood and search his house where they discovered files, scissors and various other tools associated with coining, as well as a variety of counterfeit coins. Greenwood was sent to York gaol to face trial at the next assizes.

Then a few days later, 16 July 1773, Joseph Houldsworth provided information against Thomas Murgatroyd which resulted in search of his house and some interesting discoveries.[194]

Amongst the things that were found were a pair of coining dies for coining half guineas, and old blunderbuss with the lock missing, two pistol or blunderbuss locks, a gun and gun barrel, a powder flask, and some lead shot.

The discovery of coining dies was probably not unusual, but the discovery of the weapons may have given a glimmer of hope to the people pursuing Dighton's

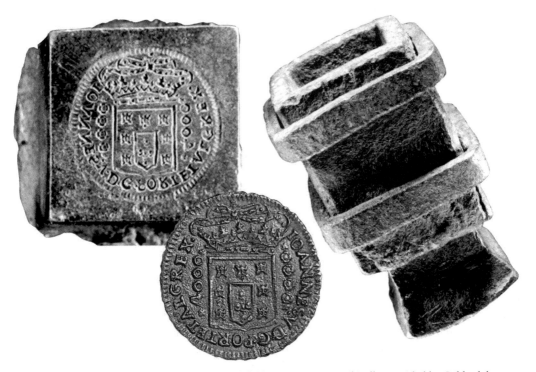

Coiners' dies and a coin on display in Bankfield Museum. (Image kindly provided by Calderdale Museums)

murderers. A marginal note written against Houldsworth's information indicated that they thought they had found the murder weapons.

Thomas Greenwood was by now already in York gaol awaiting trial, but on 28 July 1773, he put in a plea[195] together with Thomas Crampton for their trials to be postponed as two critical witnesses, Abel Wilkinson and Thomas Pickles, were not available to testify. Wilkinson was too ill to travel, and Pickles was away in the south selling cattle.

Without the support of Wilkinson and Pickles, Greenwood was ordered to remain in prison and would face his trial at the spring assizes of 1774.

By September 1773, it was apparent that the effect of the poor quality of the coin in the country was not only restricted to the area around Halifax.

An illustration of this was published in the *Leeds Mercury*[196] on 14 September 1773 regarding an agreement made by traders in Boston, Lincolnshire, who would only accept Portuguese gold coins provided they were within certain limits underweight. Due to the scarcity of silver coins, there were no restrictions placed on silver.

Two weeks later, 28 September 1773, the *Leeds Mercury*[197] published details of similar measures being taken by traders in Bradford to take genuine coins that had not been diminished but were underweight.

The suggestion was to take coins against a reduced value, to prevent genuine, undiminished coins from being clipped[198] and sent to the Bank of England, which would otherwise reduce the amount of cash in circulation.

The article then indicated that the traders of Bradford would agree to this measure provided the traders of Leeds, Wakefield and Halifax would do the same.

The extent to which the presence of clipped coins had circulated was evident by an article in the *Leeds Mercury* on 28 December 1773,[199] which indicated that despite the number of gold coins that had been collected and returned to the bank and clipped as described previously, it was acknowledged that there were still many diminished coins still in circulation.

The protests about the poor state of the coinage continued into the New Year and on 4 January 1774 a letter from a shopkeeper was published in the *Leeds Mercury*[200] which gave an indication that his customers were reluctant to pay their bills due to a considerable abundance of light money.

17

ARRESTS AND CONFESSIONS

Early in the New Year of 1774, announcements of further arrests were published in the newspapers. Men who had been pursued for some time and perhaps thought they could escape the clutches of the law were now being brought into custody.

One such arrest was that of Thomas Clayton, whose description had been given in the list of absconders that was first published on 25 November 1769.

Just over four years later, on 4 January 1774, the *York Courant* published news of his arrest and his subsequent escape from custody. Clayton had been arrested based on the information given by William Sunderland, but managed to escape from the bailiff somehow, despite being in irons.

Prompted by his escape, Clayton's description was published once more in the *Leeds Mercury*[201] on 18 January 1774.

Elsewhere in the same issue of the *Leeds Mercury* the arrest of Matthew Normanton on 10 January 1774 was also recorded. On this occasion he had been arrested on suspicion of coining.

Meanwhile in London, at the opening of Parliament on 13 January 1774, King George III's speech included a desire for the poor state of the coin to be addressed during the forthcoming Parliamentary sessions.

The speech is recorded in issue number 11422[202] of the *London Gazette* for 11 to 15 January 1774. The speech noted the rapid growth of the problem of coining but acknowledged the measures that had been taken to date which had already curbed the effects of the Coiners in the kingdom. The King warned that more needed to be done to ensure the problem did not flare up again.

In response to the King's wishes, Parliament went into committee to debate the subject in early May 1774, resulting in further resolutions being made.

Before those debates though, Thomas Clayton was finally rearrested on 28 April 1774 in Liverpool and made a statement[203] to Colonel Wickham on 2 May 1774. He claimed that Robert Thomas and Matthew Normanton had carried out the murder of William Dighton and that he had been present as a witness at the time.

Clayton claimed that he had stood on one side of Bull Close Lane with Robert Thomas and that Matthew Normanton had stood on the other side. He continued that after they had both fired their weapons, he saw Dighton fall and the two men then ran over to him and struck him with the butts of their guns and robbed him.

The next day, 3 May 1774, Robert Thomas finally confessed[204] that Isaac Hartley and Thomas Spencer had asked him and Mathew Normanton to kill Dighton for a reward of 100 pounds. He detailed how Isaac Hartley had promised to provide the weapons which he would send via Spencer.

Thomas said the men had been to Halifax twice with Spencer to try and shoot Dighton but had not seen him, and that Isaac Hartley was angry that the job had not been done. He then admitted to being present at the murder but claimed that his gun had not fired. He confirmed that Clayton was stood with him, with Normanton at the other side of the lane. Spencer was not with them this time as he had gone to a goose fair. He also admitted that Normanton had robbed Dighton's body and that the money gained had been shared with him.

Finally, he said that after he and Normanton had been sent to York gaol, they asked Spencer what had happened to the guns, and Spencer told them that Isaac Hartley had broken them up and thrown them in the River Calder.

On the same day, the 3 May 1774, Thomas Spencer made a confession[205] regarding his part in the plot, confirming that on two occasions before the murder he had visited Halifax with Thomas and Normanton, but had been unsuccessful and that on the night the murder had been committed he had intended to go to Halifax, but had not been present. Spencer also confirmed that Isaac Hartley had said that there would be a great reward for anyone who could kill Dighton, and that it was Isaac Hartley that gave him the guns to give to Thomas and Normanton.

The *Leeds Mercury*[206] on 10 May 1774 reported that Thomas Clayton had now been committed to York Castle to await trial. The same article noted that Thomas Spencer had been arrested and charged with being associated with the plot to murder William Dighton, and that Robert Thomas and Matthew Normanton had been rearrested and charged with robbing Dighton on the night of his murder.

After being acquitted previously of the murder of Dighton, Thomas and Normanton could not be charged with the same offence. Perhaps following Thomas's confession, the decision now was to charge the men with Highway Robbery in the hope of a better chance of securing a capital conviction.

PARLIAMENTARY ACTION

Around the same time as the arrests of Clayton, Spencer, Thomas and Normanton, the state of the coinage in the kingdom was discussed in Parliament in response to the request in the King's speech at the opening of Parliament in January.

The *London Chronicle* between 7 and 10 May 1774 recorded that on the arrival of Lord North (the Prime Minister), a debate took place on the subject and several resolutions were made. The case of the Yorkshire Coiners and King David was referred to directly.

A sum of £3,418,960 15s 4d was quoted regarding the value of deficient coin that had been returned to the Bank of England, but it is likely that this referred to the nation as a whole and reflected worn and clipped coins across the country.

Various resolutions were made during the meeting which described the method for valuing the gold coins according to their weight. There were also resolutions to recall the coins through appointed collectors and for the Mint to re-coin them. Other resolutions were made to discourage people from using underweight coins and there were additional provisions in relation to silver coinage.

Several resolutions resulted in a new Act of Parliament being published on 10 May 1774 (Coin Act, 14 Geo III, Chapter 70), which pronounced gold coins below a certain weight to be no longer legal.

The measures were presented by Parliament to King George III on 19 May 1774 and were published in the *London Gazette*[207] in its issue number 11458 for 17 to 21 May 1774 which summarised the measures that were being taken. The newspaper recorded the positive response of the King who was present in the house. He indicated his satisfaction at the measures presented and gave orders for the measures to be executed.

Returning to the subject of the correspondence about the murder, on 30 May 1774 Lord Apsley wrote[208] to an unnamed Lord requesting that the document referred to in a letter from Lord Rockingham be returned to him to assist in the case of the prosecution of Dighton's murderers. He suggested that it would be appropriate for the government to take up the prosecution. Apsley was Lord High Chancellor, equivalent to today's Home Secretary, and was therefore responsible for the efficient functioning and independence of the courts.

On 5 June 1774 Lord Rockingham wrote[209] a letter, again to an unnamed Lord, in which he referred to some previous correspondence which must have provided some detail on the murder and could prove useful in the prosecution of the suspects.

Samuel Lister, the Bradford solicitor, then wrote[210] on 10 June 1774 to Mr Richard Wilson, the Recorder of Leeds, in which he made his recommendations based on the information he enclosed with his letter. Lister provided transcriptions of the information given by Thomas Clayton given on 2 May 1774, and the confessions of Robert Thomas and Thomas Spencer both taken on 3 of May 1774.

He noted that Thomas and Normanton had been tried previously and acquitted, so it was too late to appeal against their acquittal. He commented that unless they could be tried again for murder, neither Isaac Hartley nor the other subscribers to the murder could be prosecuted for their parts. Lister indicated that he believed Hartley was as bad as Normanton and that the robbery was because of his instruction to commit the murder.

Lister was satisfied that the information of Clayton and Thomas was sufficient to convict Normanton, who he was sure was the man that shot Dighton, but that the testimony of Clayton alone would not be enough to convict both men. Lister believed that if Spencer could corroborate the evidence, there would be enough to convict Normanton and Thomas of the robbery.

Wilson then wrote[211] to Sir Stanier Porten, the Permanent Secretary to Lord Rochford, on 16 June 1774 to confirm that he had arranged to meet Lister to establish more information.

A few days after the meeting, on 30 June 1774, Richard Wilson sent a further letter to Lord Rochford and passed on the information[212] he had received from Lister. He suggested that with the Attorney Generals agreement, a prosecution could be secured against the men with Lister's help. Wilson's letter enclosed an account[213] of Dighton's murder from Lister which gave a summary of the events and commented on the likelihood of securing a prosecution against the men.

Lister indicated that the failure to find them guilty at the previous trial might have been due to the men having information about the evidence against them and suggested that their friends had somehow managed to get copies of the information against them.

Lister went on to describe the apprehension, escape and recapture of Thomas Clayton and the information Clayton subsequently gave relating to the murder. Again, Lister said that he thought that Isaac Hartley was the worst of them but could not be prosecuted without a murder conviction. He suggested that it could be possible for Clayton to be convicted of the murder, but then be given a pardon if he would give evidence against Hartley and the other subscribers.

In the remainder of his letter, Lister explored the possible evidence that could lead to a conviction of robbery and whether it could even be proved that a robbery took place, since all they knew was that Dighton had no money on him when he was found.

With the latest information against Thomas and Normanton before them, the law officers of the Crown reached the conclusion that these two men could now be prosecuted for the robbery of Mr Dighton.

Lord Rochford now wrote[214] to Mr Edward Thurlow, the Attorney General. Thurlow had been elected as a Member of Parliament in 1768 and was subsequently appointed to the post of Solicitor General in 1770. He then

became Attorney General in 1772 and as such he had supervisory powers over prosecutions.

Rochford enclosed the evidence passed on by Richard Wilson, the Leeds Recorder, and indicated that the prosecution of Thomas and Normanton should proceed at the Crown's expense.

The Attorney General responded[215] to Lord Rochford on 16 July 1774 and confirmed that the prosecution of Thomas could proceed but suggested that the prosecution of Normanton would be better left until another time when better evidence might be available.

With all four men in custody, the orders had been given to prosecute Thomas and Normanton for robbery. Over the following days these two men would face their trial at York alongside Thomas Spencer, who it was believed was part of the murder plot, and Thomas Clayton who was charged with coining offences.

Despite being mentioned in the correspondence numerous times, Isaac Hartley still managed to evade any action being taken against him for the part he played in the execution of William Dighton.

19

TRIAL AND CONVICTION

The assizes were opened in York on Saturday 16 July 1774 by Mr Justice Gould and Mr Justice Blackstone. The minute book[216] for the Northern Circuit General Gaol Delivery indicated that on Saturday 16 July 1774 the charges against Thomas were for feloniously assaulting Dighton and taking 4 guineas from him.

Justice William Blackstone by Thomas Gainsborough in 1774. (Bequeathed by George Salting 1910. Photo: Tate)

The charges each man faced at the assizes were also recorded in the *Leeds Mercury*[217] on 19 July 1774. Clayton was charged with possession of base and counterfeit shillings and uttering the same. Spencer was charged with paying sums of money for the murder of William Dighton and with lying in wait with the intention of shooting him. Thomas and Normanton were charged with the robbery of William Dighton.

The entry in the York Castle gaol book recorded the guilty verdict imposed on Robert Thomas for Highway Robbery and the sentence was that he was to be hanged in chains on Beacon Hill, Halifax.

The Crown and Civil minute book for the Northern and North-Eastern Circuit assizes[218] also recorded bail of £100 for Normanton on the condition that he appeared at the next assizes.

So, Normanton had been bailed, probably due to the lack of evidence alluded to in the correspondence from the Attorney General to Lord Rochford quoted previously.

The York Castle gaol book confirmed that he had been indicted for highway robbery but that the prosecution was not ready to proceed fully and that he should appear at the next assizes. Until then he was to be discharged.

Thomas Clayton and Thomas Spencer were also released.

On 26 July 1774 the *Leeds Mercury*[219] reported that the assizes had closed on 25 July and that several prisoners had been sentenced to be hanged for a variety of crimes, including Robert Thomas for the robbery of William Dighton. It also reported that Matthew Normanton had been bailed.

On 5 August 1774, the evening prior to his execution, Robert Thomas made a confession to Revd William Dade. In this confession[220] Thomas named Thomas Clayton and his wife, Matthew Normanton, Isaac Hartley and Thomas Spencer as the people that engaged him in carrying out the murder.

Thomas went on to list the people he said had subscribed to pay for the murder to be carried out, including 10 pounds from Abraham Lumb, 20 pounds from Luke Dewhurst, 20 pounds from Jonathon Bolton, 20 pounds from David Hartley and Isaac Hartley had promised to make the sum up to 100 pounds.

Thomas described the night of the murder and claimed that his gun misfired, but that Normanton's gun did fire and shot Dighton dead. Thomas then said that Normanton checked Dighton's pockets for money, which he shared with Thomas the next morning.

In the final section of his confession Thomas said that at various times he'd sent money to Normanton and Spencer, and that David Hartley had given him 15 guineas to procure counsel at his trial.

Robert Thomas was executed on Saturday 6 August 1774 at Tyburn, York. His execution was recorded in William Knipe's *Criminal Chronology of York Castle*, which noted that Thomas was hanged as an accomplice in the murder and robbery of William Dighton. It also noted that his body was conveyed to be hung in chains on Beacon Hill, Halifax.

To distinguish murder from the many crimes that carried the death sentence, The Murder Act of 1752 gave judges in England the authority to impose one of two additional punishments following execution. This was aimed at discouraging

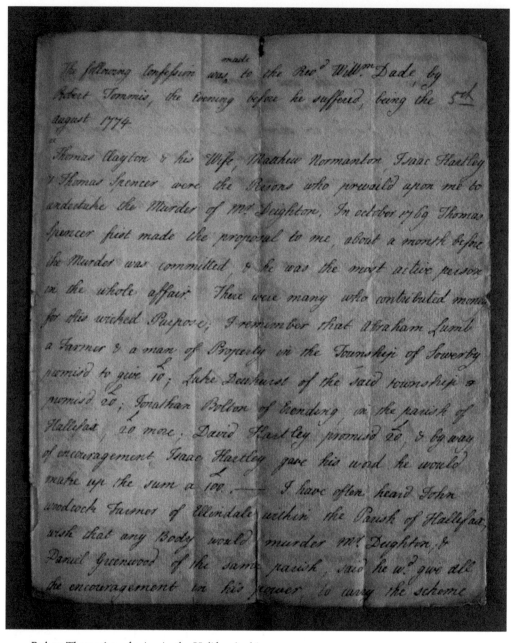

Robert Thomas' confession in the Halifax Archives.

others from committing the same crime. Criminals that had been executed for murder could not be buried without their bodies either being given to anatomists for dissection or being 'hung in chains'.

Most bodies went for dissection, but around 10 per cent of those executed were hung in chains. This practice was known as 'gibbeting', meaning that the body

was enclosed in a tight-fitting metal frame made specifically for them and hung from a tree or specially constructed frame, usually close to the scene of the crime.

In some cases, the body was coated with tar to preserve it and the body would often be left for decades until it rotted and decomposed in its frame. Naturally, due to the sight and smell of decaying corpses, the practice was not popular with residents.

The *Leeds Mercury*[221] on 9 August 1774 reported the arrival of Thomas' body in Halifax late in the evening, where there was an unsuccessful attempt by a large crowd to prevent the body from being put on display on Beacon Hill overlooking the town. The crowd had dispersed by midnight, so the officers returned at four o'clock in the morning and his body was hung within two hours. The newspaper commented that the chains his body were placed in were arranged so that Thomas' right hand pointed to the spot where he had committed the robbery.

Beacon Hill, Halifax, viewed from Halifax Parish Church.

A few days after Thomas' body was hung on Beacon Hill, another man was brought to the gaol at York Castle by habeas corpus[222] on 19 August 1774.

According to the *Leeds Mercury*[223] on 29 August 1774, a man called George Shipley had made his own confession and was charged that he had aided and assisted with the murder of Mr Dighton and had been brought from the borough of Huntingdon. Shipley was brought up before Sir Henry Gould sometime later at the York assizes in March 1776, when it was found there was no charge to answer, and he was discharged.

20

THE END OF MATTHEW NORMANTON

The main issue outstanding for the law enforcers was the prosecution of Matthew Normanton for highway robbery. He had been bailed to appear at the spring assizes of 1775 as there appeared to have been insufficient evidence to support a conviction at the previous trial.

Additional information against Normanton did come to light early in 1775 in the form of a statement[224] made by a bailiff, Jonas Shackleton, to Robert Parker on 14 March 1775. Shackleton described a meeting with Robert Thomas and Matthew Normanton around Christmas 1773 in a public house at Ripponden where they were examined by Justice Horton.

Afterwards, Shackleton had gone with Normanton, Thomas and John Sladdin to another public house in Soyland Bank, then on to another near Sowerby. As they all left together, Normanton spoke to Thomas and said that the only reason they had been caught was due to Thomas Clayton.

Because of this statement an order was made for Normanton to appear in the court at York Castle before Sir Henry Gould. Normanton failed to appear but pleaded guilty in his absence. Because of his guilty plea and in his absence, he was sentenced to death.

The minute book on 18 March 1775 recorded that Normanton had been found guilty for 'feloniously assaulting William Dighton' and for taking a guinea and a shilling from him. Normanton was sentenced to be hanged. When the constables turned up to arrest Normanton at his home at Stannery End, he escaped to a wood a short distance away but was captured near 'Spawleath' (now known as Spa Laithe).

The *York Courant* published details of Normanton's arrest in its issue of 28 March 1775.

The warrant for Normanton's execution was sent to Colonel Townley, the High Sheriff of Lancashire, who forwarded the order to Robert Parker on 12 April 1775 with a letter[225] and suggested that Normanton should be hung in Halifax instead of York as an example to the public.

Parker forwarded the order to the High Sheriff of Yorkshire, Sir George Armytage, on 13 April 1775 with a letter[226] and noted Colonel Townley's suggestion of the execution on Beacon Hill which pointed out that as the High Sheriff, Armytage had the authority to do.

Normanton confessed to his crime on 15 April 1775, to Revd John Marsden and Revd William Dade around half an hour before his execution. In the confession[227] he named David Hartley and Isaac Hartley as the people who pressed them, and that they had been promised £100 to carry out the murder. He also confirmed that

Photograph of the letter in the Halifax Archives from Richard Townley regarding Normanton's execution.

The following Confession was made by matthew
Normanton on the 15ᵗʰ of april 1775. before the
Revᵈ John marsden & the Rev ᵈ William Dade
about half an Hour before the Prisoner was carried
to the Place of Execution.

David Hartley gave me a Sum of Money to shoot
mʳ Deighton he & his Brother Isaac were the Persons who
prevailed upon me to commit the murder & David promised
me the Sum should be made up £100. We attempted
more than once to dispatch him, before the Night on which
the Deed was done & Isaac Hartley furnished me with
the very Piece that shot him, Thomas Clayton & his Wife
very often pressed upon us to attempt the Murder of mʳ
Deighton & she said, that Trade would go briskly on
as soon as ever that Exciseman was removed out of the
Way.
 Upon the word of a dying man I protest that no
other Persons were concerned actually in committing
this murder but Robert Tommis and myself, nor is it

Photograph of Matthew Normanton's confession in the Halifax Archives.

Isaac Hartley provided the murder weapon and that Thomas Clayton and his wife had also encouraged the murder, saying that their trade would go on easier with Dighton out of the way.

Finally, he confirmed that only he and Robert Thomas had been present at the murder and was not prepared to share any other information regarding clipping and coining.

Shortly after making his confession, the sentence was carried out and Matthew Normanton was executed at York Tyburn on Saturday 15 April 1775.

The *York Courant* reported the execution on 18 April 1775 and noted that he had finally confessed to his guilt and that the confession given previously by Robert Thomas was mostly true.

In line with the wishes of Colonel Townley, Robert Parker, Lord Rochford and the merchants and gentlemen they represented, Normanton's body was taken to Halifax and early on the following Monday morning it was hung in chains near the remains of his accomplice Robert Thomas.

At last, William Dighton's murderers had been brought to justice. Even though neither had been found guilty of the murder, they had both been sentenced to death and hung in chains on the hill overlooking the site of the murder.

21

COPPER AND SILVER COUNTERFEITS

By the end of 1774 and in the early part of 1775 the incidence of arrests for coining offences was now drastically reduced. This was perhaps due to a combination of circumstances.

Several prosecutions had been made to date though not many had been found guilty and sentenced. Many suspects had absconded and were still being sought. By fleeing, the gang had effectively been broken up, causing major disruption to their operations.

Traders and merchants would have been unlikely to have accepted light coins, and many carried some sort of weighing device to identify any coins that did not measure their full value. Most newspapers carried advertisements for coin balances and scales that made the process of measuring and weighing coins of various denominations easier.

The measures that had been taken to collect the bad gold coinage and reduce the value of the poor coin perhaps had the greatest effect as the Coiners would now find it increasingly more difficult to find people willing to pass or accept clipped coins.

It is likely that the Cragg Vale Coiners were now all but disbanded by this time. But this was not to say that the day of the Coiner was totally over.

With the attention of the country concentrated primarily on the state of the gold coin, it was evident from several newspaper reports that Coiners had now turned their attention to the less valuable silver and copper coins.

The reports also indicated that the methods had also changed and that plating base metal was now the preferred method. Perhaps this change in technique was an indication that a new breed of Coiner was operating in the area.

An article that was published in the *Leeds Mercury*[228] on 12 September 1775 reminded its readers of this, perhaps in the hope of dissuading those responsible from continuing their actions by reminding them of the possible consequences because the act of producing counterfeit silver or copper coins had held the same felonious status since 1771.

The full cost of prosecuting the Coiners in Yorkshire, including the murderers of William Dighton, was revealed when William Chamberlayne published the accounts of the years after 1770 on 14 November 1775.

The accounts detailed the trials and associated costs for the years 1771 (£596, 3s, 6d), 1772 (£719, 13s, 9d), 1773 (£971, 11s, 10d) and 1774 (£354, 16s, 1d).

In his memorial, Chamberlayne referred directly to the cases in Yorkshire and Lancashire. He acknowledged that the excess costs that were due to him

for bringing about prosecutions against the Coiners in 1770 had been paid by Parliament, but that the prosecutions had continued afterwards.

The introductory memorial[229] of Chamberlayne described the payments due to him for expenses incurred for carrying out prosecutions against Coiners around the country over the four years, which in total exceeded his annual allowance. He therefore applied for the additional costs to be paid.

Chamberlayne then described the extra cost of prosecuting the Yorkshire Coiners and Dighton's murderers in Yorkshire which had been accounted for separately and amounted to £897, 17s.

Chamberlayne's detailed accounts[230] went on to list the fees associated with the various prosecutions over the three years. He broke out the accounts for the cases in Yorkshire and Lancashire separately, most of which was for the prosecution of Thomas and Normanton.

It was apparent that the counterfeiting of gold coins was continuing early into 1776 when the *Leeds Mercury*[231] on 27 February 1776 described a new type of guinea that was now circulating.

A further report in the *Leeds Mercury*[232] on 12 March 1776 described counterfeit shillings made of base metal that had been plated with a layer of silver which were also in circulation.

Then on 9 April 1776, the *Leeds Mercury*[233] reported another version of counterfeit shilling in circulation that were so well made they were difficult to distinguish from genuine coins.

The government had previously published details of the acceptable weights of coins and instructions for the collection of bad coins in September 1773. Now the newspapers carried new details of the rates for coins in circulation and the arrangements for collecting the defective coin.

On 16 April 1776 a proclamation was published which prohibited the use of guineas, half guineas, and quarter guineas coined before 1772 that were deficient by certain prescribed weights. It also set a limit between 1 May to 19 August for the exchange of all underweight gold coins.

Shortly afterwards on 23 April 1776, an advertisement appeared in the *Leeds Mercury*[234] which advised the readers of the arrangements locally within West Yorkshire for the coin to be collected, listing times and places in each major town that coins could be taken and exchanged.

Another report in the *Leeds Mercury*[235] on 13 August 1776 also indicated that counterfeit guineas originating in Halifax were being produced using a copper base with gold gilding. The article advised the public to weigh all the guineas they took.

Then on 12 November 1776 the *Leeds Mercury*[236] published an indication that the amount of gold coin that had been clipped within the kingdom far exceeded the initial expectations that had been reported to the government in May 1774.

The newspaper indicated that the full extent of the under-weight gold that had been collected was four times the value that had been reported previously, indicating that the sum was in fact £16,645,847.

To put this sum into context it is possible to calculate[237] the equivalent buying power of £16,645,847 in 1776 in today's money using a series of monetary scales or indicators.

The first method would be to use the Retail Price Index, which measures the comparative cost of goods or services over a period, though this has only been officially recorded since 1948. Applying this method, the value of deficient gold coin in 1776 would equate to a value of almost £2.3 billion in 2020.

An alternative method is to compare the average earnings per capita across the same period, which would result in an equivalent value in 2020 of a staggering £27.8 billion. From this it is apparent that the problem the government faced from coining activities was a major problem.

An article in the *Leeds Mercury*[238] on 29 July 1777 reported on an article in the *Newcastle Chronicle* regarding counterfeit guineas in circulation in Yorkshire, particularly in the North Riding. The article said the coins were full weight but looked pale and the letters were poorly executed.

Then 26 August 1777 the paper reported that counterfeit sixpences were in circulation, but that they had no impression on one side, were larger than genuine coins and that they were worth not much more than half a penny.

Subsequently on 9 September 1777 the same paper announced the government's plans to withdraw all the silver coins from circulation. So, the government now found it necessary to take the same precautions with silver as it had done with gold, forcing a wholesale recoinage of silver.

22

THE END OF THE COINERS

The last significant prosecutions for coining offences in the area took place in the summer of 1782, when John Cockroft, Thomas Greenwood and John Wood faced charges at the York assizes on 13 July 1782.

Cockroft had been arrested and charged with coining offences previously in 1769 but was one of the men discharged at that time. He had been charged with further coining offences again in 1778 and again escaped conviction on a technicality.

His previous experiences had apparently not deterred him but this time the new indictment[239] alleged that he had been caught red-handed passing a counterfeit silver coin.

The brief[240] against Cockroft noted that he had been one of the people committed previously to York gaol on suspicion of coining and that he had since taken to making counterfeit shillings. It also noted that in 1778 he had been committed to Lancaster gaol for counterfeiting halfpence but was acquitted due to a mistake in the prosecution.

The brief gave details about the circumstances of his arrest and indicated the incriminating evidence found in his possession when his house was searched.

Cockroft was caught by surprise and was making counterfeit shillings when the searchers arrived. The search located no fewer than 449 counterfeit shillings in various stages of completion and a variety of tools used for the purpose.

Thomas Greenwood was charged on four counts, for coining a Portuguese moidore, for clipping a moidore, for possession of a coining press, and for counterfeiting a halfpenny.

The details of the case against John Wood are not contained in the Halifax Archives, other than a slip of paper which lists the indictment against him for coining a shilling alongside the indictments against Thomas Greenwood and John Cockroft.

The *Leeds Intelligencer*[241] recorded the sentence against the men, and in its issue of 23 July 1782 the paper reported that because of the charges against them, all three men were convicted and sentenced to be executed.

Despite their apparent fate, the *Leeds Intelligencer*[242] reported on 22 August 1782 that the three Coiners had been reprieved on condition that they were transported for life to a penal colony in Africa.

With the action taken to collect bad gold coin, the ability of the Coiners to produce counterfeit gold coins was significantly reduced.

A brief Account of the leading Transactions of the Lives of

Thomas Spencer and Mark Sattonstall

The two Convicts who are sentenced to be executed upon Beacon-Hill, near Halifax, on Saturday the 15th of August, 1783, for being concerned in the late Riots in the Town and Neighbourhood of Halifax aforesaid.

THOMAS SPENCER was born and brought up about five miles west of Halifax, in that plot of ground which has been peculiarly famous for many years past, for producing COINERS, NIGHT HUNTERS, THIEVES, ROBBERS and MURDERERS. Hence may be formed a tolerable good idea of the complexion of his education. About twenty-six years since he enlisted into the thirty-third regiment of foot, whence he was discharged about two years afterwards with pension, having been wounded. He returned to his old companions; it would be needless to say to his and their former practices. In the year 1769, when Coining, Dissipation, &c. were in their meridian in his native soil, and when their career was a little curbed by the late unfortunate Supervisor, Mr DIGHTON, some of the capital practitioners in the YELLOW TRADE, who from their birth knew Spencer, and from their nocturnal connections were intimately acquainted with his daring principles, applied to him to murder Mr DIGHTON, and told him if he would undertake to do the deed, he should be amply rewarded. Immediately he applied to Robert Thomas and Matthew Normanton, (whose gibbets are now standing on Beacon Hill, and who were two of his intimates) to join him in executing that diabolical deed; they readily closed with his proposals, and all three agreed, if their employers would secure to them One Hundred Pounds they would engage to execute the matter. The bargain was struck; Spencer received a Guinea in part of payment; they three came that night Thursday, October 1769, to BULL-CLOSE, near Halifax, where Mr DIGHTON lived, (Spencer having previously brought to Matthew Normanton's house two short guns, three pistols, some slugs and gunpowder) but were disappointed of their intention, returned home and spent the Guinea. On the 3rd of November following, Spencer brought another Guinea, and persuaded Thomas and Normanton to accompany him to Bull-Close to do the needful; and that night Spencer had his piece levelled to shoot Mr DIGHTON thro' the window as he stood by his kitchen fire; a person passing by at that instant prevented his firing. They returned without executing the Deed. And on the fatal ninth of November, 1769, when Normanton shot Mr DIGHTON, Spencer positively promised to meet him and Thomas as soon as supper was over, but broke his word, preferring the COINER'S GOOSE FEAST at Mytholmroyd Bridge to the assassination of an innocent man, being fully persuaded he had left the business in proper hands. On Saturday the 11th Spencer came to Halifax to learn if possible who was suspected to be the murderer; the next morning he went to Thomas and told him he was in danger of being apprehended on an account of the murder, having been at Shaw's the night DIGHTON was killed. About the 24th of November, (Thomas and Normanton being then confined in YORK CASTLE on suspicion of being the Murderers) Spencer carried Eight Guineas to them, assuring them no money should be wanting in case they would only keep their own council, and desired to know where the guns and pistols were, which they told him were in THOMAS CLAYTON'S CLOSE. On his return home he went with an acquaintance, found them and threw them into the River Calder.

Since that time till June 7th 1783, not anything very material marked this convict's conduct; but on that day as the rioters were proceeding in their passage from Wadsworth to Halifax, Spencer joined them and proposed to head them; they readily embraced his offer; and when they were just entering the town he called out to them STOP MOB; the command was instantly obeyed, Spencer then formed them two deep, and in that order headed them down the principal street, till they came opposite the White Swan Inn, where he formed them; then headed them thro' the Corn Market, and to the Boar's head Inn, where it was expected the largest quantity of corn was lodged; there again he ordered the MOB to stop till he had spoken to Mr Anderton the Master of the Inn, his command was again obeyed; Spencer then insisted that Mr Anderton should sell the Corn lodged in his Warehouses, viz. Oates at Thirty-Shillings per load, and wheat at One Pound one Shilling; and if he refused they would enter his warehouses and take the corn into the market and sell it; but Mr Anderton, as the corn was not his own property, prudently refused either selling it or opening the warehouse doors; Spencer did not think fit to break the locks, but headed the MOB into those parts of the town where the corn carts and wagons were standing, and were others was expected to come. A very large quantity was sold by the MOB at Spencer's Price, and the owners suffered to receive the money where they could get it; this being done Spencer then commanded the MOB to go into the public roads leading to the town, and bring back such carriages loaded with corn as were returning home, and durst not enter the town for fear of having their grain sold at such prices as these desperadoes thought proper to fix, which they instantly obeyed and effected without fear of the fatal consequences that hence ensued.

MARK SATTONSTALL was born in the same famous plot of ground with his brother convict, was taken from his parents when forty weeks old by some relations of the same place, and brought up by them till the year 1782, when he enlisted into the thirty-third regiment of foot, now quartered at Halifax, being then only seventeen years of age; which regiment he served honestly six months, when by a reducement in the said regiment he was discharged; and unfortunately for him was in company with Spencer on Sunday the 8th day of June 1783, and was by him prevailed upon to join the mob the next day.

Recreation of a handbill regarding Spencer and Sattonstall.

The escalation of the offence of coining copper and silver coins to felony status also meant that it was no longer worth risking their necks for such small gains. The coining activities died a natural death and the reign of the Coiners in Yorkshire finally came to an end.

Thomas Spencer and Isaac Hartley had on numerous occasions been named within various statements and confessions in connection with the murder of William Dighton. Thomas Spencer had been tried for his part in the murder alongside Robert Thomas and Matthew Normanton at their second trial in 1774 together with Thomas Clayton. He had confessed to going with Robert Thomas and Matthew Normanton on two occasions prior to the murder but had been at the Goose Feast in Mytholmroyd on the night that the murder was finally committed. He had escaped justice so far.

In 1783 several riots took place in the West Riding of Yorkshire over the cost of corn, and the towns of Leeds, Bradford, Halifax and Huddersfield all saw a variety of protests and actions against the corn suppliers to obtain corn for bread.

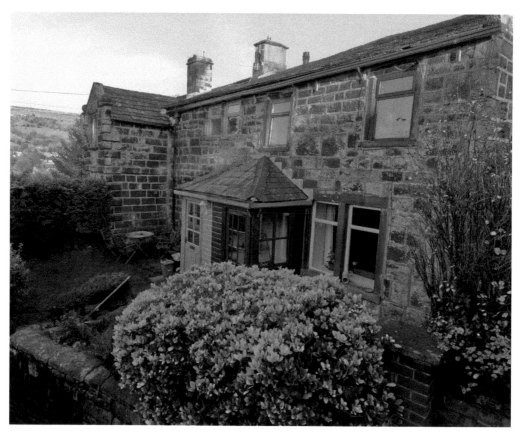

Photograph of New House, the home of Thomas Spencer.

In Halifax an angry mob gathered in the town, determined to raid the corn warehouses. As the handbill on the previous page describes, Spencer made his way to the front of the mob and commanded them to stop, which they did.

He was joined by another man, Mark Sattonstall, and together they organised the rioters and led them forward through the Corn Market to the Boars Head Inn where they challenged one of the traders, threatening to raid the warehouses if the corn and wheat was not sold at the rates they demanded.

The riots in the various towns were described in the *Leeds Intelligencer*[243] in its issue of 17 June 1783 which also indicated that the two leaders of the corn riots in Huddersfield had been arrested and within twenty-four hours had been imprisoned in York Castle.

The paper then indicated that the two leaders of the Halifax riot, Spencer and Sattonstall, had been arrested and sent to York.

Some weeks later the *Leeds Intelligencer*[244] brought news of the fate of both men when it reported in its issue of 12 August 1783 that they had been found guilty and sentenced to death.

Spencer and Sattonstall were executed on 15 August 1783 on Beacon Hill in Halifax, alongside the place where the gibbeted remains of Thomas and Normanton still hung in their chains.

Their executions were recorded in the issue of the *Leeds Intelligencer*[245] on 19 August 1783. Spencer was noted as being fifty-six years of age with Sattonstall only nineteen years old. After their death, their bodies were cut down and given to their friends for burial.

The last moments of Spencer's life were also recorded in another printed document held in the Halifax Archives. This 'last and dying confession'[246] was undated but indicated that he had been involved in the plot to kill Dighton. On the night in question though he had been at a goose fair.

Shortly before his execution Spencer supposedly made a speech warning other Coiners from their 'sinful practices' and that his shameful death might be a sufficient warning to them.

Contained within the series of notes made by Francis Alexander Leyland was an account of Spencer's execution from a witness who was present on the day. Elizabeth Walton spent some time with Leyland discussing the Coiners and recounting her recollections.

In the first part of the notes made by Leyland during his visit Mrs Walton also described being a witness to the death of the last of the Coiners.

Isaac Hartley was the man who had escaped justice despite being named so frequently by the murderers and witnesses in their evidence. Many of the depositions had confirmed that he was the man responsible for collecting and contributing to the £100 used to pay the murderers. It was also claimed by some that he was the man who had obtained the weapons and had disposed of them after the murder.

Despite all of this he had escaped the clutches of the law and finally died an old man at the age of seventy-eight on 5 March 1815 at his home at White Lee

The laſt dying Speech and Confeſſion of Thomas Spencer, who was executed at Halifax, on Saturday the 16th day of Auguſt, 1783.

THOMAS SPENCER was a native of Luddenden, near Halifax, in Yorkſhire; he was one of a notorious character, and one who agreed to murder Mr. Dyton, ſupervifor, of Halifax, but happened to be at a goofe-eating, when the unfortunate ſupervifor was murder'd; neverthelefs, he had an equal ſhare of one hundred pounds, gathered by a ſet of coiners, as a bribe for the horrid crime of murder. The crime for which he ſuffered, was for rioting, breaking open a box, and taking money thereout. When he was brought to the bar to take his trial, he was ſoon found guilty. The judge exhorted him in the moſt ſolemn manner to prepare to meet the great Judge of all the earth; after which he paſſed ſentence, and told him, that he muſt be taken to the place from whence he came, and from thence to be moved alive to Halifax, and on Saturday the 16th of Auguſt, to executed at Halifax, and afterwards to be hung in chains on Beacon Hill. At the place of execution he appeared very penitent, entreating God to have mercy upon his ſinful ſoul, before it was ſeparated from his body, and that in a very importunate manner. He exhorted every ſpectator, and particularly coiners, &c. to leave off that ſinful practice, and flee from every known ſin; and eſpecially to watch againſt the various temptations of the devil, by whom he had been led captive, and that his ſhameful death might be a ſufficient warning to them; and that they would be careful not to put off repentance and turning to God in their dying moments.

If men did but conſider their latter end, and that they have ſouls that muſt run parellel with eternity, they would not leave the vaſt concern thereof to their dying moments. God declares in his holy word, to day if ye will hear my voice, harden not your hearts; and again, Behold, now is the accepted time, and behold now is the day of ſalvation. God offers mercy to-day; and, ſince this is the caſe, what folly and madneſs it is for the children of men to ſlight his offered mercy, as they cannot tell what an hour may bring forth. Poor, thoughtleſs mortals, Death is making long ſtrides towards you, and you are haſtening to meet him, and the grave, as faſt as the wings of time can carry you. Break off your ſins by repentance, and forfake every evil work, and begin to entreat God, that he would make you a partaker of that redemption, which is only by faith in Jeſus Chriſt, before you go hence, and perfevere therein, then it will be well with you in time and to all eternity.

Photograph of the 'last and dying speech and confession' of Thomas Spencer in the Halifax Archives.

in Mytholmroyd. He was buried in the graveyard at the Church of St Thomas a Beckett, Heptonstall, on 8 March 1815 next to the grave of his brother 'King' David.

Mrs Walton's recollections of Isaac Hartley's death were recorded by Leyland in his notes[247] on 12 October 1856, which then went on to describe Mrs Walton's account of the executions of Spencer and Sattonstall and the return of their bodies to Mytholmroyd and Heptonstall.

Mrs Walton remembered the coining activities of her childhood and recalled that she and other children[248] had seen Isaac Hartley on his death bed, rolling in pain and groaning as his elderly wife tottered around the room muttering about her own infirmities.

Elizabeth Walton also remembered the execution of Spencer and Saltonstall at Halifax and that the bones of Thomas and Normanton still hung in their chains alongside the execution site with their right hands pointing to the murder site.

Leyland's notes paint a vivid picture of the execution of the two men and their subsequent journey to burial. Reference is made once again to Isaac Hartley's involvement in the Coiners gang as a 'hirer of assassins'.

Clearly Isaac Hartley suffered a terribly painful death. Ling Roth noted that he had been unable to discover what caused this agony. My grandfather claimed Isaac had died of cancer. It is something we will probably never know, but this undoubtedly brought an end to the last of the Cragg Vale Coiners.

But what became of the men that brought the Coiners and William Dighton's murderers to justice?

The solicitor Robert Parker died on 23 May 1796 and was buried at Halifax Parish Church. After his part in the Cragg Vale Coiners story, he remarried and a white marble memorial to Robert Parker and his second wife, Mary, can be seen on the west wall of the Holdsworth Chapel in Halifax Parish Church. The gravestone itself is located elsewhere in the Holdsworth chapel.

Also located in a grave at the entrance to the Holdsworth Chapel are the remains of Coroner Thomas Hyde, who took the various statements after William Dighton's murder. He died on 5 February 1796.

Lord Rockingham had previously been appointed Prime Minister in July 1765. In July 1766, sometime before his involvement in the Coiners story, he had resigned from office because he discovered that the King had secretly been negotiating for William Pitt to form a ministry.

In March 1782, on the resignation of Lord North, King George III had no choice but to appoint Rockingham as Prime Minister for the second time. This second ministry lasted only fourteen weeks though as Rockingham died on 1 July 1782.

The one person whose end remains a mystery is James Broadbent, the informant. No mention is made of him after his release from York Castle after the autumn assizes of 1770 and I have been unable to trace any record of his death or burial.

The man whose actions brought so many Coiners in front of a JP and whose contradictory statements almost led to the failure to prosecute William Dighton's murderers appeared to have vanished.

Before leaving the story of the Yorkshire Coiners though it is worth visiting one final piece of information contained in the notes of Francis Alexander Leyland,[249]

White Lee in Mytholmroyd, where Isaac Hartley died in 1815.

Memorial to Robert Parker, Halifax Parish Church.

if for no other reason than it adds a humorous twist to the pattern of informants we have seen throughout this book.

It concerns some notes taken by Leyland on 15 October 1869 during a meeting with a man named Joseph Jagger in Halifax, who told Leyland of an unusual source of information against the Coiners. Jagger claimed that his great-aunt, Mrs Ambler, kept a public house called the Cross Pipes, often frequented by the Coiners, and where James Jagger had been arrested the same night as David Hartley.

Mrs Ambler kept a very vocal parrot which was often heard to say 'Come out you coining thieves! Come out you coining thieves – You coining rogues!' The parrot was then heard to utter names such 'Coining David, King David, come in! Come in coining Greenwood! Coining thieves, coining rogues, come out you coining thieves!'

Perhaps the downfall of the Coiners resulted less from the evidence of the Coiners and the informants around them and more from the parrot that resided in the public house that some of the gang members chose to frequent.

23

CONCLUSION

The Cragg Vale Coiners had a significant effect on the value of the currency of the kingdom. No doubt clipping and coining was taking places in other parts of the country, but it is unlikely that it was anything like the organised scale of this gang and was generally carried out by individuals or small, discreet groups.

The difference in Cragg Vale was the number of people involved and the support the Coiners gained by ensuring that it was not only the Coiners that made a profit, but anyone assisting them in their activities also benefited.

Most of the local populace in the area were farmers using weaving to supplement their meagre income. The various statements and documents confirmed that the occupations of the people involved were generally related to the woollen or worsted trades, and draw boy weavers, stuff makers, shalloon weavers, and wool combers are common throughout.

In 1771, a woven 'piece' would sell in Halifax for around 11 pence, but this was reduced to around 8 pence by 1774.[250] It could take up to eighty hours a week to produce a piece, so the income from weaving was very low in proportion to the skill and effort involved.

The Coiners' policy of paying an extra shilling for an unclipped guinea enabled those not directly part of the gang to boost their own income without necessarily taking part in the act of coining itself.

By taking around 40 pences' worth of gold from each guinea, the Coiners would only need to clip around seven coins to gain enough to mint their version of a Portuguese moidore with a face value of 27 shillings (using only 22 shillings' worth of gold). This only cost the Coiners 7 shillings, making a substantial 20-shilling profit on every new coin they made.

Coining was profitable work provided there was a ready supply of unclipped coins, so the payment of the locals that were willing to provide the gold was a key factor in the Coiners' rapid success.

With their self-created wealth and their lofty abodes, the leaders of the gang no doubt thought they could escape the clutches of the law and indeed probably thought they were above it.

The remoteness of the farms and homesteads where the coining took place made it difficult for the authorities (who knew who the ringleaders were) to make any progress in catching the Coiners in the act.

The only means open to them was to pay informants to expose those involved, and the authorities found several willing to do so, perhaps on the promise of better rewards than the Coiners themselves offered.

James Broadbent was the first in a long succession of informants tempted either by a reward, or in some cases a need to secure a pardon from the crimes they themselves were charged with.

This brought about considerable success to the extent that it created sufficient threat to the Coiners' business for them to take dramatic action. The leaders were probably already plotting to prevent any more of their number being taken by getting rid of William Dighton, but when David Hartley was arrested the Coiners' plans were hastened.

The murder of William Dighton occurred within three weeks of David Hartley's arrest and was completed on the third attempt, so it is reasonable to assume that it had been premeditated before Hartley was imprisoned. It is still possible that he influenced these actions whilst he was imprisoned in York since records confirm that Isaac Hartley travelled to see his brother on several occasions.

Dighton's murder was a significant error on the part of the Coiners. Up until then he had only made a few arrests and no prosecutions had resulted. Whilst he probably knew who the primary members of the gang were, he was working largely alone and in no official capacity.

The Coiners possibly naively thought the murder would go unnoticed outside their area of rule. In fact, it attracted the attention of those at the very highest levels of power within the kingdom, bringing greater attention upon themselves and their unlawful activities.

This led to their downfall, with the dispatch of officials from the Mint to Yorkshire, with the intention of preventing the coining and bringing Dighton's murderers to justice. Those officials took effect swiftly, no doubt helped by the increased rewards available to those prepared to inform against the Coiners and acting on the information Dighton had established and probably shared with Robert Parker.

The men who committed the murder were quickly apprehended and a case built against them. Unfortunately, the willingness of James Broadbent to change his story to protect himself tripped the prosecution up on the first occasion.

But the authorities knew the murderers had escaped and a determination to see justice served eventually paid off, so whilst Robert Thomas and Matthew Normanton were not convicted of murder they were eventually hanged for their crime by an alternative means.

In parallel with the pursuit of the Coiners gang, the precautions taken by the government to recall the bad coin had the effect of reducing the acceptability of poor coin. This raised public awareness regarding the use of light coins and discouraged those around the Coiners who had previously lent good coins and returned bad coins to circulation.

The chain of supply for gold coin was broken, so the Coiners could no longer continue their profitable trade in clipped and counterfeit gold coins.

With the focus of attention on the gold coin, those members of the gang that were left turned their attention to coins of lesser denominations, until new legislation made the offence equal to that of coining gold currency. This in turn brought about further prosecutions and at last, the end of the Cragg Vale Coiners.

That so few Coiners were executed is an indication of the significance of hanging David Hartley, which the authorities carried out as an example to those members further down the chain of command.

Apart from David Hartley and James Oldfield, the only other members of the Coiners gang to suffer at the gallows were those involved directly or indirectly in the murder of William Dighton – but all for charges other than murder. Robert Thomas and Matthew Normanton had been hanged not for murder but for the highway robbery of Dighton, and Thomas Spencer for leading the Halifax bread riots rather than his part in the conspiracy.

Several other members of the gang had been found guilty at various times and sentenced to death but received a reprieve of one sort or another. William Varley had been sentenced to hang alongside Hartley and Oldfield but was reprieved and later pardoned; John Bolton had also been sentenced to death and was given a reprieve shortly after; and John Cockroft, John Wood and Thomas Greenwood all had their death sentences commuted on condition of their transportation to Africa.

One question that might remain is whether the Coiners became rich because of their activities. There is no evidence that indicates what the total benefit was to the leaders of the gang.

In Ling Roth's book, he observed that the records of Francis Alexander Leyland contain a note that he had been told by Mr John Waterhouse that he had seen a ledger that had been kept by the Coiners. This ledger apparently recorded the various transactions that took place between the Coiners and their 'depositors'.

Waterhouse denied Leyland the opportunity to see the ledger as it might implicate senior members of society in the area. Waterhouse also mentioned a piece of paper which had apparently held money to bribe Dighton's daughter to keep quiet after her father's murder.

The ledger would give the best indication of how much trade in coins was conducted by the Coiners, so giving an indication of the potential profits they made because of their activities.

Whether the ledger still exists and whether it ever did at all is unknown and no record exists of it in the local archives. It would make fascinating reading if it could be traced, and it would be interesting to read which families it implicated. The likelihood is that it has long since been lost or destroyed.

The only indication of apparent wealth I have been able to trace comes perhaps in the probate records relating to David Hartley and his widow, Grace.

At the time of his execution, Hartley had died intestate, without making a will. As a result, an Administration Bond was issued to Grace Hartley, Abraham Sunderland (a shopkeeper), and Henry Sutcliffe (a yeoman). This meant that as administrators of Hartley's estate, they were legally bound to pay a set amount if they failed to administer the estate honestly and faithfully.

The bond was made on 16 May 1770, just eighteen days after the execution of David Hartley, and is held in the Borthwick Institute of the University of York.

Grace Hartley had six months to provide an inventory of David Hartley's estate, or she and her co-administrators would be liable to pay the sum of £500 (equivalent today of £679,648 using a comparison of average earnings). This amount was typically twice the estimated value of the estate, ensuring that the administration was carried out correctly.

This bond potentially gives an indication of the value of David Hartley's estate at the time of his death. The inventory that Grace Hartley subsequently deposited would give a true indication of its value.

The jurisdiction for probate lay with the Exchequer Court of York, the records of which were deposited with the Borthwick Institute at University of York between 1958 and 1960.

A search of the Probate Register at the Borthwick Institute revealed that Grace Hartley did deposit the inventory of David Hartley's estate in June 1770, a month from the date of the bond, but unfortunately a copy of the inventory itself does not exist within the records.

Alas the true value of David Hartley's estate may never be known, but an indication of Grace Hartley's access to capital, probably from the proceeds of coining, came on 13 January 1774, when she bought Lodge Farm in Erringden for £260 from John Walker.

David Hartley's father, William, died in 1774, bringing his tenure at Bell House to an end, so Grace Hartley moved her family to Lodge Farm, a short distance over the hill from Bell House.

Lodge Farm, which Grace Hartley bought in 1774.

Perhaps this gives an indication that the family surrounding David Hartley were comparatively well-off and rather than being tenants, as David Hartley's father had been at Bell House, they had in fact become landowners themselves.

Presumably, this was the result of their success as the leaders of the Cragg Vale Coiners.

24

FILM, FICTION AND TELEVISION

This book would not be complete without mentioning some of the recent developments in the story of the Cragg Vale Coiners which have made them the subject of a historic fiction novel that is being dramatized for television, and a separate project which may also result in the story being portrayed on the big screen.

The development of this book began because of a project to produce a feature film entitled *The Last Coiner* which is inspired by the events surrounding the gang. The man behind the project is Peter Kershaw, writer, director and producer of Duchy Parade Films.

In a unique approach to film-making, specialists and historians were involved at an early stage to ensure that the script was historically informed and accurate. All too often, experts would only be consulted during production of a film, by which time it is usually too late for their advice to be effective.

Through the securing of a grant from the Arts and Humanities Council (AHRC), Peter Kershaw enlisted the support of Dr Hannah Greig, a lecturer in eighteenth-century British history, and Dr Nick Tosney, Postdoctoral Research Assistant from the University of York History Department.

The grant funded a series of five workshops held during October and November 2009, with the first four in Halifax and the final one at the York Castle Museum. These brought together experts from various fields, together with local historians and other interested parties to discuss the lives of the Coiners and the influences behind their coining activities.

As a descendant of David Hartley, I was fortunate to have been invited to attend the workshops. As I had several existing publications on the subject, I started to put the story and its documents into chronological order to inform the script process. In doing so I established that there was much more information in the archives that had never been published, so I began the task of locating and transcribing the huge amount of additional material, which ultimately resulted in the development of this book.

These thought-provoking workshops gave a useful insight into the normal lives of the Coiners and the circumstances which prompted them to take up their activities.

Since the workshops took place Peter Kershaw has relocated to New Mexico and completed a master's degree in film writing. He has worked on other film projects with the objective of attracting funding for *The Last Coiner* feature film to eventually become a reality.

In the intervening time since these workshops, the Cragg Vale Coiners have also been the subject of a historic fiction novel, by writer Benjamin Myers. *The Gallows Pole* tells the story in a very dark, imaginative manner and conveys a brutality that the Coiners were conceivably capable of. *The Gallows Pole* won the 2018 Walter Scott Prize for historical fiction and has received glowing reviews from all quarters. It has also generated new interest in the Cragg Vale Coiners from people who were previously unaware of the story.

In May 2021 it was announced that the BBC had commissioned a dramatization of the book, to be adapted for a TV series by acclaimed film director Shane Meadows. The development of this TV series brings the story of the Cragg Vale Coiners to a much wider national and potentially international audience. Filming started in late 2021 using a combination of established actors and actresses and a wealth of new talent. During the completion of this book, I've been privileged to have met many of the main performers and witnessed some of the filming taking place. Whilst it will be told with a degree of artistic licence, it is genuinely exciting to see the story brought to life for television.

NOTES

1. Clipping and coining are two distinctly separate actions. Clipping is cutting the material off the edge of coins. Coining is the manufacture of counterfeit coins.
2. The Treason Act 1351 Chapter 2, Regnal 25, Edward 3, Stat 5
3. The Treason Act 1708 Chapter 21, Regnal 7
4. McLynn, Frank, *Crime and Punishment in the Eighteenth Century* (London: Routledge, 1989) chapter 9, pp. 167–171
5. Brewer, John & John Styles, *An Ungovernable People: The English and Their Law in the Seventeenth and Eighteenth Centuries* (London: Hutchinson & Co., 1980)
6. See the letter from the Marquis of Rockingham to Lord Weymouth on 1 December 1769
7. Rogers, Ruding, B. D. *Annals of the Coinage of Britain and Its Dependencies* (London: Nichols, Son and Bentley: 1817-1819)
8. Hanson, Thomas William, *The Story of Old Halifax* (Halifax: F. King & Sons, 1920) chapter XIV, pp. 189–190
9. The parish records at Heptonstall list David Hartley as a webster (weaver) at the time of his marriage in 1764.
10. WYAS HAS:1400 (463)/27 – Innkeeper Bates information.
11. *Clip a Bright Guinea*, p. 22. Marsh acknowledged that no record of this meeting exists.
12. The family and estate papers of the Wentworth, Watson-Wentworth and Fitzwilliam families.
13. WWM/R11/11
14. WWM/R11/12 & TNA/SP82/85 folio 165
15. WWM/R11/13
16. TNA/SP37/7/118
17. LCL/MF 97504/5
18. LCL/MF 97504/5
19. LCL/MF 97504/5
20. Deposition – the giving of sworn evidence
21. TNA/ASSI/45/29/3/43
22. LCL/MF 97504/5
23. LCL/MF 97504/5
24. LCL/MF 97504/5

25. LCL/MF 96442
26. Styles, John, *An Eighteenth-century Magistrate as Detective: Samuel Lister of Little Horton* (The Bradford Antiquary, 1982) Volume 10, pp. 98-117, of the second series.
27. TNA/ASSI/45/29/3/98
28. TNA/ASSI/29/3/30
29. TNA/ASSI/29/3/31
30. TNA/ASSI/29/3/32
31. There is no record of a prosecution against Crispin Crowther in the assize records or in the accounts of William Chamberlayne for the trials of 1770.
32. TNA/ASSI/45/29/3/27
33. TNA/ASSI/29/3/35
34. TNA/ASSI/45/29/3/41
35. TNA/ASSI/45/29/3/29
36. TNA/ASSI/45/3/26
37. TNA/ASSI/45/29/3/28
38. TNA/ASSI/29/3/36
39. TNA/ASSI/45/29/3/37
40. TNA/ASSI/45/29/3/38
41. TNA/ASSI/45/29/3/39
42. TNA/ASSI/45/29/3/42
43. TNA/CUST/47/221 folio 50
44. TNA/CUST/47/225 folio 22
45. TNA/CUST/47/225 folio 37
46. See Broadbent's statement of 13 November 1769
47. LCL/MF 96442
48. In his statement of 13 November 1769, Broadbent indicated that he had been asked on different occasions whether he would give information against David Hartley and James Jagger.
49. TNA/ASSI/29/3/34
50. LCL/MF 96442
51. LCL/MF 96442
52. LCL/MF 96442
53. TNA/ASSI/29/3/33
54. TNA/ASSI/45/29/3/40
55. See the information of Thomas Greenwood and John Sladdin in September 1771.
56. Contained in the confession of Robert Thomas on the 5 August 1774, the night before his execution.
57. See Broadbent's statement on 13 November 1769, WYAS HAS:1400(463)/9
58. See the confession of Robert Thomas on 3 May 1774.
59. WYAS HAS:1400 (463)/20 and TNA/ASSI/45/29/3/208
60. WYAS HAS:1400 (463)/18
61. WYAS HAS:1400 (463)/9
62. WYAS HAS:1400 (463)/19
63. WYAS HAS:1400 (463)/21

64. LCL/MF 97504/5
65. See the examination of Jonathon Oldfield, 21 November 1769.
66. LCL/MF 96442
67. TNA/CUST/47/269 folio 116
68. TNA/SP44/142 folio 222
69. WYAS HAS:1400 (463)/3 and www.london-gazette.co.uk
70. LCL/MF 96442
71. WYAS HAS:1400 (463)/22 and TNA/ASSI/45/29/3/201-204
72. WYAS HAS:1400 (463)/10 and TNA/ASSI/45/29/3/183-188
73. WYAS HAS:1400 (463)/17
74. WYAS HAS:1400 (463)/16
75. LCL/MF 96442
76. LCL/MF 97504/5
77. TNA/ASSI/45/29/3/207
78. Located on Rawson Street and now renamed Somerset House.
79. WWM/R11/1
80. WYAS HAS:1400 (463)/11
81. WWM/R11/2
82. WWM/R11/14
83. WWM/R11/5 and TNA/SP37/7/114-115
84. TNA/ASSI/45/29/3/61
85. WWM/R11/6 and TNA/SP37/7/116
86. LCL/MF 96442
87. LCL/MF 97504/5
88. TNA/SP37/7/107-112
89. LCL/MF 96442
90. TNA/SP37/7/119-120
91. TNA/SP37/7/127-128
92. TNA/SP37/7/129
93. TNA/SP37/7/130
94. TNA/SP37/7/121
95. TNA/T29/40 folio 129-130
96. Augustus Henry FitzRoy, 3rd Duke of Grafton. He became Prime Minister at the age of thirty-three in 1768 and stepped down in 1770, handing over power to Lord North.
97. Frederick North, 2nd Earl of Guilford, was Prime Minister of Great Britain from 1770 to 1782. At the time he was the Chancellor of the Exchequer and leader of the House of Commons.
98. Charles Jenkinson. At the time he was Member of Parliament for Appleby and one of the Junior Lords of the Treasury.
99. TNA/SP37/7/123 and TNA/T29/40 folio 130-131
100. TNA/SP37/7/122
101. WWM/R11/20
102. WWM/R11/19 and TNA/SP37/7/125-126
103. TNA/SP37/133
104. WWM/R11/22

105. This explains how the extracts came to be contained in the Sheffield Archives.
106. WWM/R11/23
107. WWM/R11/7
108. The Treason Act 1708 Chapter 21, Regnal 7
109. TNA/ASSI/45/29/3/80
110. TNA/ASSI/45/29/84
111. TNA/T/1/472
112. LCL/MF 96442
113. TNA/ASSI/45/29/3/58
114. WWM/R11/3
115. LCL/MF 96442
116. TNA/ASSI/45/29/3/59
117. TNA/ASSI/45/29/3/60
118. TNA/ASSI/45/29/3/65
119. HAS:1400 (463)/14
120. TNA/ASSI/45/29/3/57
121. TNA/ASSI/45/29/3/25
122. TNA/ASSI/45/29/3/45
123. TNA/ASSI/45/29/3/46-50
124. TNA/ASSI/45/29/3/51-54
125. LCL/MF 96442
126. TNA/ASSI/45/29/3/55-56
127. TNA/ASSI/45/29/3/66
128. WWM/R11/10 and TNA/SP37/7/135-136
129. TNA/ASSI/45/29/3/64
130. TNA/ASSI/45/29/3/62-63
131. TNA/ASSI/45/29/3/67-70
132. LCL/MF 96442
133. TNA/T29/40
134. LCL/MF 96442
135. The Coin Act 1696 (8 & 9 Will 3, Chapter 26) – *An Act for the better preventing the counterfeiting of the current coin of this Kingdom*, which came into effect on 15 May 1697.
136. TNA/ASSI/45/29/3/71
137. TNA/ASSI/45/29/3/82
138. TNA/ASSI/45/29/3/72-73
139. TNA/ASSI/45/29/3/75-76
140. TNA/ASSI/45/29/3/77-78
141. WWM/R11/26
142. Innkeeper of the Wheat Sheaf in Halifax. His arrest was announced in the *Leeds Mercury* of 21 December 1769.
143. Spelter – a zinc-lead alloy, often used to make candlesticks
144. WYAS HAS:1400 (463)/27
145. TNA/ASSI/45/29/3/81
146. TNA/ASSI/45/29/3/83

147. TNA/ASSI/45/29/85
148. TNA/ASSI/45/29/3/86-93
149. TNA/ASSI/45/29/3/96
150. TNA/ASSI/45/29/3/97
151. TNA/ASSI/45/29/3/74
152. TNA/ASSI/45/29/3/95
153. TNA/ASSI/45/29/3/94
154. LCL/MF 96442
155. WYAS HAS:1400 (463)/24
156. LCL/MF 97504/5
157. LCL/MF 97504/5
158. LCL/MF 96442
159. TNA/ASSI/41/6
160. TNA/ASSI/41/6
161. See the list appended to the letter from Robert Parker on 18 April 1770.
162. LCL/MF 96442
163. WYAS HAS:1400 (463)/25
164. WYAS HAS:1400 (463)/5 and within TNA/ASSI 44/85
165. LCL/MF 96442
166. LCL/MF 97504/5
167. TNA/SP44/89 folio 356
168. TNA/ASSI/45/29/3/246
169. A warrant for them to be arrested to ensure they make a scheduled court appearance.
170. LCL/MF 96442
171. WYAS HAS:1400 (463)/29)
172. TNA/ASSI/45/29/3/112e
173. TNA/ASSI/45/29/3/112c
174. TNA/ASSI/45/29/3/112f
175. TNA/ASSI/45/29/3/112b
176. WYAS HAS:1400 (463)/26
177. WYAS HAS:1400 (463)/15
178. WYAS HAS:1400 (463)/29
179. YAS/MS385
180. LCL/MF 97504/5
181. TNA/ASSI/41/6
182. LCL/MF 97504/5
183. LCL/MF 97504/5
184. TNA/T/1/483/96
185. TNA/T/1/483/95a
186. WYAS HAS:1400 (463)/31
187. WYAS HAS:1400 (463)/32
188. TNA/T29/42 folio 96-97
189. TNA/29/43 folio 75
190. WYAS HAS:1400 (463)/33
191. WYAS HAS:1400 (463)/34

192. LCL/MF 96442
193. WYAS HAS:1400 (463)/35
194. WYAS HAS:1400 (463)/38
195. WYAS HAS:1400 (463)/35
196. LCL/MF 96442
197. LCL/MF 96442
198. In this instance, the term 'clipped' refers to the Bank of England practice of cutting into the coin up to halfway across its diameter to signify that it was underweight.
199. LCL/MF 96442
200. LCL/MF 96442
201. LCL/MF 96442
202. www.london-gazette.co.uk
203. WYAS HAS:1400 (463)/43 and TNA/SP37/10/202
204. WYAS HAS:1400 (463)/40
205. WYAS HAS:1400 (463)/36
206. LCL/MF 96442
207. www.london-gazette.co.uk
208. TNA/SP37/7/200-201.
209. TNA/SP37/7/202-203
210. TNA/SP37/7/204
211. TNA/SP37/10/208
212. TNA/SP37/10/210
213. TNA/SP37/10/211-216
214. TNA/SP37/7/198-199
215. TNA/SP37/10/218-219
216. TNA/ASSI/41/6
217. LCL/MF 96442
218. TNA/ASSI/41/6
219. LCL/MF 96442
220. WYAS HAS:1400 (463)/43
221. LCL/MF 96442
222. Habeas Corpus – a legal action, or writ, through which a person can seek relief from the unlawful detention of him or herself, or of another person. It protects the individual from harming him or herself, or from being harmed by the judicial system.
223. LCL/MF 96442
224. WYAS HAS:1400 (463)/48
225. WYAS HAS:1400 (463)/45a
226. WYAS HAS:1400 (463)/45b
227. WYAS HAS:1400 (463)/46
228. LCL/MF 96442
229. TNA/MINT 1/12 Folio 310 & 311
230. TNA/MINT 1/12 Folio 312 & 313
231. LCL/MF 96442
232. LCL/MF 96442

233. LCL/MF 96442
234. LCL/MF 96442
235. LCL/MF 96442
236. LCL/MF 96442
237. Source and calculations: www.measuringworth.com, calculated the equivalent values up to 2020
238. LCL/MF 96442
239. WYAS HAS:1400 (463)/55
240. WYAS HAS:1400 (463)/58
241. LCL/MF 97504/9
242. LCL/MF 97504/9
243. LCL/MF 97504/9
244. LCL/MF 97504/9
245. LCL/MF 97504/9
246. HAS:1400 (463)/60
247. HAS:1400 463/63
248. Mrs Walton appears to imply she was a child at the time, yet in 1815 she would have been forty-one years old. This would account for her seeing Spencer's body in its coffin in 1784.
249. HAS:1400 463/63
250. Ashton, Thomas Southcliffe, *An Economic History of England: the Eighteenth Century* (London: Methuen & Co. Ltd, 1972).

BIBLIOGRAPHY

Baumber, Michael Leslie, *Revival to Regency: A History of Keighley and Haworth 1740-1820 Volume One* (Keighley: Baumber, 1983)

Brewer, John & John Styles, *An Ungovernable People: The English and Their Law in the Seventeenth and Eighteenth Centuries* (London: Hutchinson & Co., 1980). *Our Traitorous Money Makers: The Yorkshire Coiners and the Law 1760-83.*

Hanson, Thomas William, *The Story of Old Halifax* (Halifax: F. King & Sons, 1920)

Knipe, William, *Criminal Chronology of York Castle* (London: C. L. Burdekin, 1867)

Ling Roth, Henry, *The Yorkshire Coiners, 1767-1783, and Notes on Old and Prehistoric Halifax* (Halifax: F. King & Sons Ltd, 1906)

Marsh, John, *Clip a Bright Guinea* (London: Clarke, Doble & Brendon, 1971)

McLynn, Frank, *Crime and Punishment in the Eighteenth Century* (London: Routledge, 1989)

Styles, John, *An Eighteenth-century Magistrate as Detective: Samuel Lister of Little Horton* (The Bradford Antiquary, 1982)

The Halifax Antiquarian Records Collection: Cragg Vale Coiners, held by the West Yorkshire Archive Service: reference HAS:1400 (463)

The State Papers Domestic, George III, held by the National Archives, Kew.

Records of Justices of Assize, Gaol Delivery, Oyer and Terminer, and Nisi Prius, Northern and North-Eastern Circuits held by the National Archives, Kew.

ACKNOWLEDGEMENTS

I must thank several people for their assistance and encouragement in writing this book, especially Peter Kershaw of Duchy Parade Films for inviting me to take part in the workshop series for *The Last Coiner*. During those workshops I am indebted to the many contributors who provided such useful background to the Coiners story, much of which has been incorporated into this book.

Thanks therefore go to Peter Kershaw, Dr Hannah Greig, Dr Nick Tosney, Professor James Sharpe, Professor Edward Royle, Dr John Hargreaves, Professor Patricia Hudson, Dr Catherine Bradley, Dr William Ashworth, Dr Anne Murphy, Dr Katie Eagleton, Professor John Styles, Katherine Prior, and finally to Mary Kershaw and the staff at York Castle Museum.

I am also extremely grateful to the many members of the Cragg Vale Local History Group, Hebden Bridge Local History Society and the Cragg Vale residents who attended the workshops and expressed an interest in this book, to Diana Monahan, Shirley Daniel and Ann Lindsay.

Thanks also go to Nathan and Elizabeth Smith, former residents of Bell House, whose determination to restore the derelict barn at Bell House to provide accommodation for walkers and include a Coiners display finally saw their application make its way through the planning maze and become reality.

Many thanks also to Eli Dawson, Curator from the Calderdale Museums, for providing photographs of the Coiners' tools that are now on display at the Bankfield Museum, Halifax.

I must thank the staff at the West Yorkshire Archive Service at the Halifax Public Library, Leeds Central Library, Sheffield City Archives, the Yorkshire Archaeological Society and the National Archives in Kew for their assistance in locating and providing access to the various original documents upon which much of the content of this book is based.

Finally, many thanks to my cousin Jonny Thynne who created the fantastic illustration of Bell House on the cover of this book. Jonny shares the same relationship as me to King David Hartley through his mother, but in a peculiar twist through his father's family, may also be related to Lord Weymouth, Thomas Thynne, one of the politicians that supported bringing the Coiners to justice.

ABOUT THE AUTHOR

Steve Hartley was born in Leeds, West Yorkshire, in 1966. The son of a policeman and a court clerk, he grew up in Otley, a few miles north of Leeds. He is married with three children and now lives in Northampton. He is a project manager for a UK construction contractor.

Steve's grandfather Maurice Hartley lived in Eastwood, a short distance along the Calder Valley from Hebden Bridge, until his death in March 2006 at the age of ninety-one.

Maurice had drawn up a family tree some years earlier, tracing the link back as far as David Hartley's father, William. Maurice also had a copy of another family tree recording the branch that was descended from another of David Hartley's sons.

Visits to see Maurice would inevitably involve a discussion about the Coiners at some point, particularly during later years when Steve Hartley started researching the family tree further and merged the two separate family trees into one.

When Maurice Hartley died, the collection of old family photographs, extracts from the family bible, probate documents, birth, marriage and death certificates and a copy of the book by Henry Ling Roth passed to Steve Hartley and prompted him to develop a website, www.yorkshirecoiners.com. This website briefly describes the story of the Coiners.

The website attracts correspondence from all over the world from researchers either trying to trace relatives who might have been associated with the Cragg Vale Coiners or from those who are just fascinated by the story.